WATERCOLOR FOR THE *fun* OF IT

Painting People

Michaelin Otis

NORTH LIGHT BOOKS
CINCINNATI, OHIO
www.artistsnetwork.com

About the Author

Michaelin Otis has owned her own gallery and teaching studio, Avalon Arts, for thirteen years. A Signature member of the Taos National Society of Watercolor and the Northern Plains Watercolor Society, she is an active member in the Northstar Watercolor Society and the Minnesota Watercolor Society. Michaelin teaches workshops worldwide, including yearly classes in Yucatán, Mexico. Her portraits appear on CD covers for Tom Tipton and Beverly Dorsey. She has written several articles for national art publications and competes in national shows, where she has won numerous awards. Her work can be seen at Avalon Arts, White Bear Lake, MN, at avalonarts-gallery.com and artshow.com, as well as in several galleries across the country. You can reach her at 651-429-4489 or by e-mail, michaelin@avalonartsgallery.com.

Watercolor for the Fun of It: Painting People. © 2005 by Michaelin Otis. Manufactured in China. All rights reserved. No part of this book may be reproduced in any form or by any electronic or mechanical means including information storage and retrieval systems without permission in writing from the publisher, except by a reviewer, who may quote brief passages in a review. Published by North Light Books, an imprint of F+W Publications, Inc., 4700 Galbraith Rd., Cincinnati, Ohio 45236. (800) 289-0963. First edition.

Other fine North Light Books are available from your local bookstore, art supply store or direct from the publisher.

09 08 07 06 05 5 4 3 2 1

Library of Congress Cataloging-in-Publication Data

Otis, Michaelin.
 Watercolor for the fun of it : painting people / Michaelin Otis.
 p. cm.
 Includes index.
 ISBN 1-58180-560-8 (pbk)
 1. Human figure in art. 2. Watercolor painting--Technique. I. Title.
ND2190.O87 2005
751.42'242--dc22

2004050141

Editor: Gina Rath
Cover design by: Eric Vincent
Art Director: Wendy Dunning
Production Coordinator: Mark Griffin

METRIC CONVERSION CHART

to convert	to	multiply by
Inches	Centimeters	2.54
Centimeters	Inches	0.4
Feet	Centimeters	30.5
Centimeters	Feet	0.03
Yards	Meters	0.9
Meters	Yards	1.1
Sq. Inches	Sq. Centimeters	6.45
Sq. Centimeters	Sq. Inches	0.16
Sq. Feet	Sq. Meters	0.09
Sq. Meters	Sq. Feet	10.8
Sq. Yards	Sq. Meters	0.8
Sq. Meters	Sq. Yards	1.2
Pounds	Kilograms	0.45
Kilograms	Pounds	2.2
Ounces	Grams	28.4
Grams	Ounces	0.04

WATERCOLOR FOR THE *fun* OF IT
Painting People

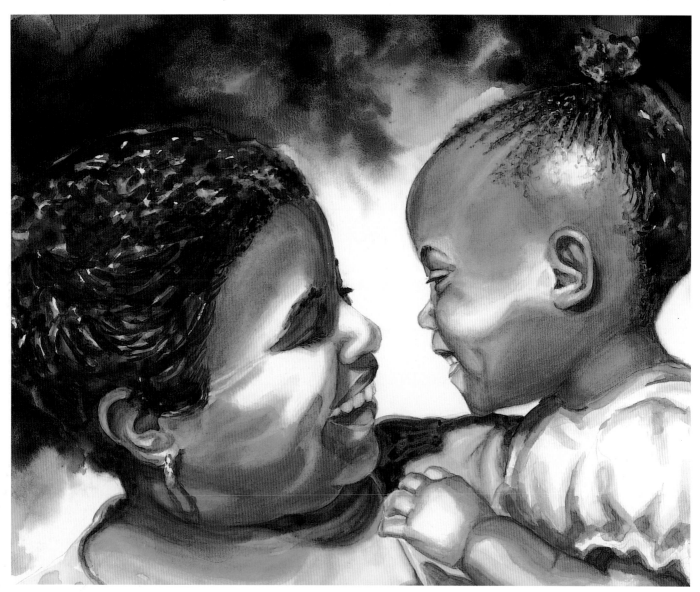

STEPHANIE AND AJAH • 12" x 15" (30cm x 38cm) • Collection of Mr. and Mrs. Adrian Walker

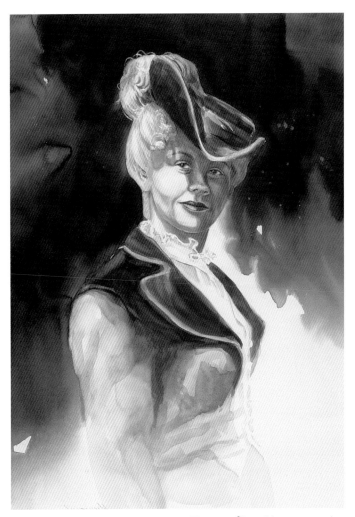

Dedication

This book is dedicated to my mother, Marjory Meinhardt—my friend, my first painting student, and my biggest cheerleader. I miss you deeply. You truly were "The Belle of the West."

Acknowledgments

Writing a book can be a daunting task, and I would like to thank all those who made this possible. Special thanks to both of my editors: Pam Wissman who proposed the idea to me, convinced me I could do it, and got me started; and to Gina Rath, who was with me every step of the way, made writing a book really fun, and was a pleasure to work with. Thanks to all of my wonderful long time students, who have taught me far more than I have ever taught them. And, of course, a special heartfelt thank you to the love of my life, my husband, Jim, without whom I would never have had the courage to become a full-time artist.

BELLE OF THE WEST • 16" x 12" (41cm x 30cm) •
Collection of the artist

Table *of* Contents

1) DRAWING and shapes

Learn how to draw, measure, and compare to create an amazing likeness of your subject. By following the step-by-step demonstrations in this chapter, you will learn how to draw and paint facial features from all angles. You will also learn how important shape and value are for creating a likeness.

2) painting SKIN and HAIR

Learn which paint colors make the best skin tone colors for all types of skin. Two mini-demos will allow you to practice Michaelin's favorite hair color mixtures to achieve exciting, lifelike hair.

3) working from PHOTOS

Learn how to use photography to best show off your paintings of people. You will learn how to crop photos and incorporate the background into the foreground to make a stronger compositional statement. You will also find out what to watch out for when taking and choosing a photo to help you make a great painting.

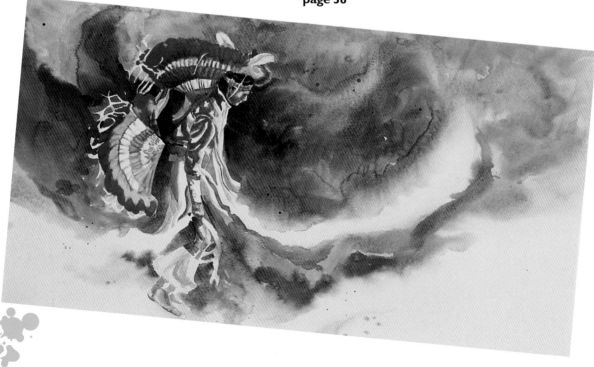

SPIRIT DANCE • 24" x 32" (61cm x 81cm) • Collection of the artist

4) painting ADULTS

With these step-by-step demonstrations, you will learn how to paint a variety of facial angles and skin colors as well as adults of different ages. You will learn how to add pizzazz and excitement to your portraits and how to incorporate the personality of your model into every portrait that you paint.

page 46

5) painting CHILDREN

Capturing the personality of children will become easy and fun with these five step-by-step demonstrations. Included are children of many ages in a variety of poses. Learn how to paint a standing youth, children playing, and a group of little cowboys.

page 70

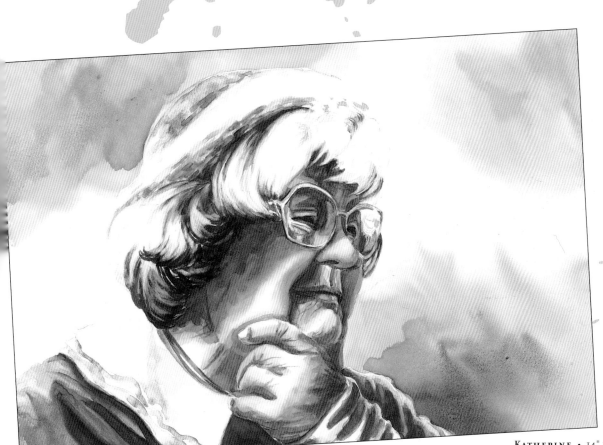

KATHERINE • 14" x 10" (36cm x 25cm) •
Collection of the artist

Introduction

My mother always told me that I started drawing the day I was born. Actually, that is a bit of an exaggeration. I had polio as an infant, so Mom needed a way to keep me content during the many doctor visits that followed. She found she could give me a pencil and paper and keep me happy for hours. I still draw every day, and while I do feel that drawing and painting are learned skills, the more you practice, the better you will become. Anyone can learn to draw and paint if they are willing to take the time. Just like learning to play the piano, if you practice, you will learn. Not every piece will end up a concerto; neither will every painting end up in a frame. But you will love the journey. ✿ This book is designed for you to do the projects in order, as they get a bit more difficult in the later pages. Feel free to trace the drawings in the beginning. Tracing is a good way to learn how to see the shapes and reproduce them. Learning to draw is actually learning to see things in shapes rather than seeing the actual objects. Watercolor painting takes practice, as does any medium. No medium is harder than another; oils are no easier than watercolor. They are just different in technique and final result. ✿ There are many wonderful subjects to paint, but people are my favorite. There is something much more emotional to me in paintings of people rather than a landscape or still life. Of course, every artist is different, and hopefully you are reading this book because you feel the same. ✿ I hope you will have fun doing the lessons in this book and get as excited as I do when capturing a bit of someone's soul on a piece of paper.

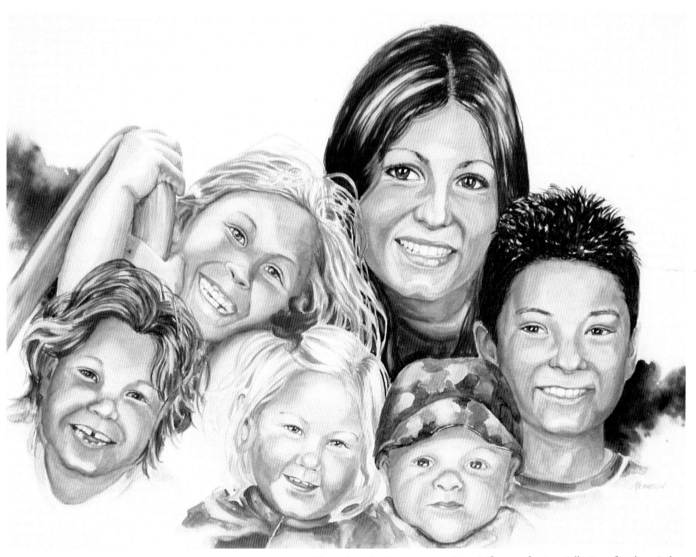

FUN GRAU'S DELIGHT • 24" x 30" (61cm x 76cm) • Collection of Barbara Stakes

A Quick Start Guide

Basic Supplies

These are the minimum items you need to get started in watercolor.

Palette

A plastic palette with a lid works best. It is very portable and the lid keeps the palette clean. The palette shown has thirty-two large wells which allows you to use large brushes.

Paints

There are many good brands of watercolor, but Holbein is the brand that I prefer. It stays very workable in the palette and makes very rich, creamy color. Holbein allows me to achieve the dark, rich colors that I like in my paintings.

When you are setting up your palette, squeeze out about half of the tube onto the palette. Save the rest of the tube for when your paint runs low or when you want to use a little fresh paint.

My palette is arranged according to warm and cool colors (see page 13). I place all the warm colors on one side and cools on the other. To help you remember the colors and their location, you may want to label the colors on the side of your palette with a permanent marker.

The colors listed here are the colors I use in this book, including background colors. You can certainly paint with fewer colors if you wish.

Tube Colors

- Aureolin (two—one for mixing, one to stay clean)
- Indian Yellow
- Cadmium Yellow Lemon
- Permanent Red
- Carmine (two—one for mixing, one to stay clean)
- Opera
- Vermilion (or Brilliant Orange)
- Burnt Sienna
- Raw Sienna
- Payne's Grey
- Sap Green (optional)
- Shadow Green (optional)
- Cerulean Blue
- Turquoise Blue
- Royal Blue

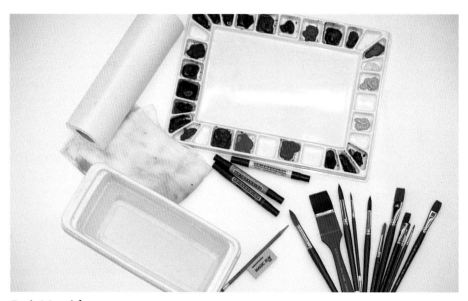

Basic Materials

A palette such as the Jones Palette shown above, has thirty-two large wells, which make it possible to use large brushes. The brushes here are Stratford & York Kielder brushes. They are synthetic, last a long time, are reasonably priced and hold lots of water and color.

- Ultramarine Deep
- Cobalt Blue
- Bright Violet

Brushes

There are many good watercolor brushes on the market, and every artist will tell you they like different ones. I have tried many of them, and my favorite are Stratford & York Kielder Series Watercolor Brushes. These also come from Holbein. These brushes hold lots of water and pigment, last a long time and are also about half the price of sable brushes. All of these brushes are synthetic but feel very much like sable. Sable is great and is often recommended for watercolor painting, but sable seems to wear out quickly for me.

Here are the brushes I use most often:

Round-Stratford & York Kielder Series

- No. 4
- No. 6
- No. 8
- No. 10
- No. 14

Flat-Stratford & York Kielder Series

- 1-inch (25mm)
- 3/4-inch (19mm)
- 5/8-inch (16mm)
- 1/2-inch (12mm)
- 1/4-inch (6mm)

(see flat brush demonstration below)

Paper

Here is where I differ from a great many artists. I like to paint on Strathmore 500 Series Vellum Illustration Board. It is very forgiving and never needs stretching, like cold-pressed papers. Best of all, you can lift off color. That can be a problem when you want to add several layers, but this book will teach you how to add layers without lifting. The techniques used here also work on cold-pressed paper, but you will find that colors stay brighter on watercolor board; I think you will love it and never go back to regular paper. This watercolor board comes in sheets that are 30" x 40" (76cm x 102cm), and you can cut it to the size you want.

Other Miscellaneous Supplies

- Water container
- White paper towels or tissues
- No. 2 pencil
- White plastic eraser
- Markers in black and gray for value studies

Tip When you have a color that you love to mix with, like Aureolin, make two wells of that color. Then you have one clean and one to mix with. Carmine is another color that mixes well and should have two spaces.

USING A FLAT BRUSH

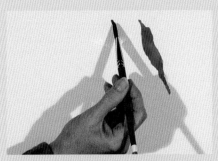

Painting with a flat brush will allow you to paint interesting shapes. Start with just the tip of the brush touching the paper. Begin with light pressure.

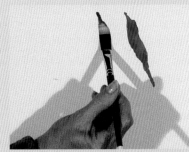

As you pull the stroke along, apply more pressure to flatten the bristles of the brush against the paper.

Lighten your touch and lift back to just letting the tip of the brush touch again. Because you do not have as much control over the flat edge as you would with a round brush, it forces you to paint looser, creating more interesting shapes.

Basic Watercolor Techniques

Making a Color Wheel

Begin by drawing a triangle on a piece of board. Then put the three primary colors at each corner of the triangle: Royal Blue on one corner, Permanent Red on another and Aureolin on the last. Now add the colors that fall between the primary colors: Add Sap Green between the yellow and blue, Vermilion between the yellow and red, and Bright Violet between the blue and red. You now have the secondary colors. You can see that yellow is the complement, or opposite color, of violet (complements are indicated with a dotted line). When you want to tone down or gray down a color, you add a touch of its complement. If you mix an equal amount of two complements, you will get a gray. Mix some Ultramarine Deep and Burnt Sienna (which is an orange) and add a dab of gray in the center of your color wheel. You now have a handy reference to keep with your materials.

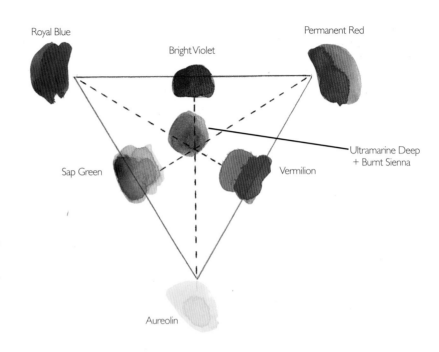

Royal Blue

Bright Violet

Permanent Red

Ultramarine Deep + Burnt Sienna

Sap Green

Vermilion

Aureolin

Applying a Wash

A *wash* (a) is a very thin first layer of paint that is applied to wet or dry paper. Bring some paint out onto the mixing area of your palette and make a diluted mixture with just a little paint and a lot of water. Fill your brush with this wash mixture and apply.

When painting on dry paper, start at the top and work down. When painting on wet paper, first apply water to the paper with a large brush, making sure the paper is very shiny and wet, with no puddles. Start your wash while the surface is shiny wet. When the shine starts to soak in, stop and dry the surface. You can always rewet after the surface dries completely and start again.

What is a Glaze?

A *glaze* (b) is the same as a wash but is a second coat of either the same or a different color. Each glaze will become darker than the last. Make sure the first wash is completely dry before adding another layer. You can use a hair dryer if you are impatient.

Lifting Color

You *lift color* (c) by dabbing with a dry paper towel while the paint is still wet. If the paint is dry, use a wet brush to dampen the area you want to lift off and dab the area with a dry paper towel. Or you can use a damp brush to lift off the color. A damp brush is a brush that is filled with water and then dried off a bit so it feels just damp and not soaking wet. You will find that color lifts off much easier on this surface than on traditional cold-pressed paper.

Softening an Edge

Softening an edge (d) is done when a strong, sharp edge is not wanted. If the paint is still wet, run a damp brush along the edge of the paint. Make sure that the brush does not have too much water in it. If the paint is dry, you can still soften by wetting the edge with a damp brush and then wiping the edge with a paper towel.

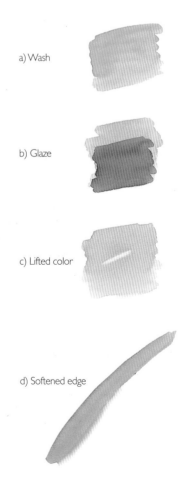

a) Wash

b) Glaze

c) Lifted color

d) Softened edge

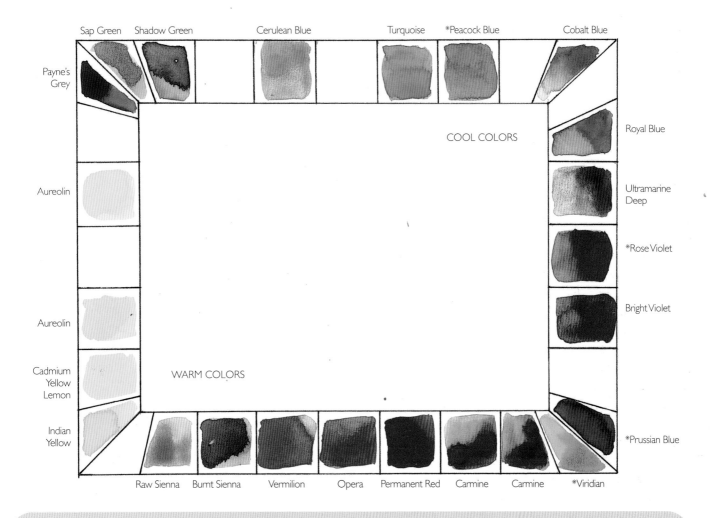

Sap Green　Shadow Green　　Cerulean Blue　　　　Turquoise　*Peacock Blue　　Cobalt Blue

Payne's Grey

COOL COLORS

Royal Blue

Aureolin

Ultramarine Deep

*Rose Violet

Aureolin

Bright Violet

Cadmium Yellow Lemon

WARM COLORS

Indian Yellow

*Prussian Blue

Raw Sienna　Burnt Sienna　Vermilion　Opera　Permanent Red　Carmine　Carmine　*Viridian

PREPARING AND MIXING COLORS

When painting with watercolor, you don't use paint taken directly from the wells in your palette. You first bring the paint out into the mixing area of your palette, dilute it with water and make sure it is all dissolved.

To set up your palette, squeeze the colors into the separate wells of your palette, starting with the warm colors and continuing around to the cool colors as shown. Squeeze out about half of the tube into the wells and let dry overnight without the lid. This will set up the color, making it easier to work with; you want the paint in the wells to feel dry to the touch. After the colors are dry, they are ready for you to use. Wet your brush, and using a circular motion, stroke your brush into a dried color in one of the wells. This activates the paint and your brush is now loaded. Bring the color out into the mixing area and, using the same circular motion, make a puddle of paint. Thin the puddle to the consistency of thin milk by dipping the brush back into the water and adding water to the puddle. The color is now ready to use for a wash.

To mix a different color, rinse your brush thoroughly and activate

the color in a different well just as you did with the first color. Take your loaded brush and mix that color into the puddle of color already out in your mixing area. Keep adding color until the desired mixed color is achieved.

Some great mixtures to try:

◉ Ultramarine Deep and Burnt Sienna—Great dark, almost black. By varying the amount of blue used, you can mix anything from a gray to a dark brown.

◉ Carmine and Viridian—Green-black or red-black. Holbein Viridian is the same color that other brands call Phthalo Green.

◉ Aureolin and Payne's Grey—Olive green

◉ Carmine and Payne's Grey—A great purple

◉ Opera and Cerulean Blue—Pale lavender

*Color not used in this book.

Basic Techniques

When starting any type of stroke with watercolor, you always have the option of painting on wet or dry paper. The decision is yours; usually you will want to paint small areas on dry paper and larger areas on wet. Painting on wet allows you more time to finish the area or play around in it by adding or removing color. If the surface starts to lose its shine, you need to get out of that area until it dries (this is very hard for all of us); then you can rewet and start painting again.

The only alternative to this rule is to use thicker and thicker paint in your brush with less and less water (with less water in your brush you will not make any puddles in your drying paint). You will learn more about this later in this book.

In the following step-by-step demonstration you will practice some basic watercolor techniques: the wash, glazing, softening edges and mixing up some skin tone colors. Just relax and have fun getting to know watercolor!

[MATERIALS LIST]
Small piece of illustration board

Paints
- Raw Sienna
- Ultramarine Deep
- Carmine
- Burnt Sienna

Brushes
- No. 4 round
- No. 8 round

Other Supplies
- No. 2 pencil
- White eraser

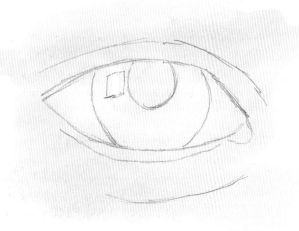

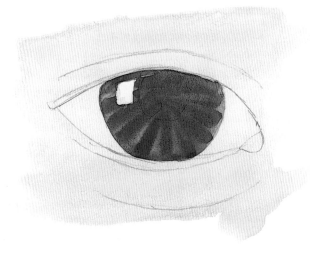

1 | **Draw an Eye and Apply the First Wash**
Practice the techniques by painting an eye. Draw an eye in pencil on a small piece of illustration board. Prepare your colors—mix Raw Sienna with a touch of Carmine to make a skin tone. The color should be about the consistency of thin milk. Using your no. 8 round, wet the entire eye and surrounding skin, leaving the highlight in the pupil dry. Paint a very weak, diluted wash over the whole area, leaving the highlight white. If it appears too dark, dab the white of the eye with a paper towel to lift some color. Let dry completely.

2 | **Glaze in the Iris**
With a no. 8 round, glaze in the iris and pupil with a thinned mixture of Ultramarine Deep. While the paint is still wet, streak in the iris with thicker and darker paint. Stroke from the outside edge of the iris in to the center. Paint right over the pupil. Remember to leave the highlight white.

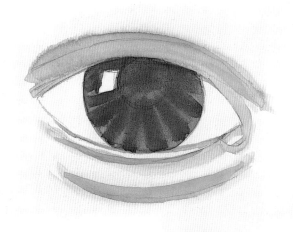

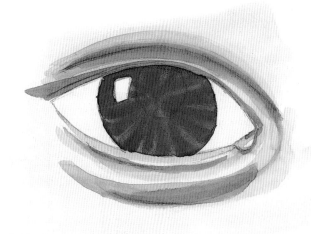

3 | **Glaze in the Shadows and Soften the Edges**
Mix a darker version of the Raw Sienna and Carmine skin tone color (from step 1). With your no. 8 round, paint darker shadow shapes in the skin area around the eye. Soften the edges of these shapes with a damp brush.

4 | **Create a Darker Skin Tone**
Create a darker skin tone by mixing some Burnt Sienna into the skin tone mixture on your palette. With your no. 8 round, add the darkest skin tones in the creases above and below the eye. You can soften again if you like, but it is not necessary.

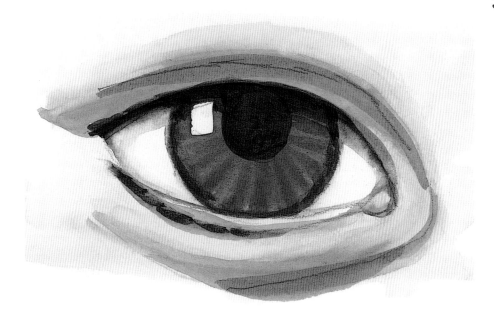

5 | **Glaze in Darks and Details**
Using your smaller no. 4 round, make a thick, almost black mixture of Burnt Sienna and Ultramarine Deep. Make sure it is very thick and has little water (it should be the consistency of thick cream). Paint the pupil and along the top of the eye under the lid. Soften with a damp brush (not wet) and pull some of the gray down to form a shadow in the white of the eye. Because the white of the eye has a bit of skin tone on it, the only pure white left should be the highlight of the eye.

Darken around the iris with the black mixture and soften where necessary. Use the dark skin tone to paint in the tear duct. You have now painted a lifelike eye while practicing your techniques.

DRAWING
and shapes

Drawing is really seeing the shapes that are in front of you. Do not draw what you think is there, draw the shapes you actually see. Contrary to popular belief, you can be taught to see specific shapes to draw. It just takes practice. ❧ If you are drawing from a photograph and having a hard time drawing a shape correctly, turn the photograph upside down and draw it upside down on your paper. This forces you to see actual shapes rather than seeing an eye or a nose. ❧ The most important thing you can do to improve your painting is to practice drawing. It is impossible to do a good painting from a poor drawing. ❧ Start with a person you do not know rather than someone you are very familiar with. For your first few drawings, do not worry about getting a likeness. Have fun and don't put too much pressure on yourself. Drawing should be a relaxing time, not a chore. The more you draw, the more proficient you will become.

THE LAST ONE IN • 20" x 30" (51cm x 76cm) • Private collection

Measuring and Comparing

Drawing faces is not as daunting a task as you might think. It is simply a matter of measuring and comparing shapes to each other. There are many methods of drawing faces. The described method is the one that I find the easiest. Some artists start with an egg shape and go from there, but I find it easiest to start with the eyes. Once the eyes are right, everything else is compared to them.

For this lesson, use the photo presented here. Later you will want to draw from your own photos. When you do use your own photos, make sure they have good light and dark shapes. This is easiest to achieve when taken in direct sunlight, rather than using a flash. Make a copy of the photo, enlarging it up to 8" x 11" (20cm x 28cm). If you do not have a copier, take it to a local printer. It is much easier to measure on a larger picture than on a regular-size photo.

[MATERIALS LIST]

⊚ Small piece of illustration board

⊚ No. 2 pencil

⊚ White eraser

⊚ Ruler

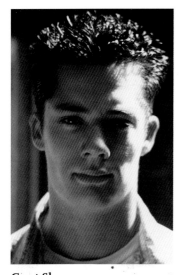

Great Shapes

This photo has great shadow and light shapes. It is a bit difficult to see the eye that is in shadow, so simply measure the eye that you can see, then make the other eye the same width.

1 | **Sketch the First Eye**
To begin the drawing, first visualize where you want the head located on the paper. You will be drawing just the head for now. Decide where you want the eyes; the eyes are located exactly halfway down the face. Sketch in one eye, estimating the size. (After you draw a few faces, this part will get much easier.) Make sure you really look at the shape of your subject's eye and draw the shape you see, not what you think you see.

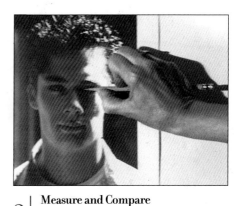

2 | **Measure and Compare**
You now have one eye drawn on your paper and you need to position the other eye. The average face measures exactly one eye width between the eyes. Since faces vary, measure and compare the eyes in the photo. With your pencil, measure the eye on the photo by placing the point of the pencil on the inner corner of the eye. Place your thumbnail on the pencil at the outer corner of the eye; this gives you the measurement of one eye on the pencil. Without moving your thumb out of position, move the pencil and measure the area between the eyes (from the inner corner of the same eye to the inner corner of the other eye). In this photo, there is slightly more than one eye width between the eyes, so transfer this information to the drawing.

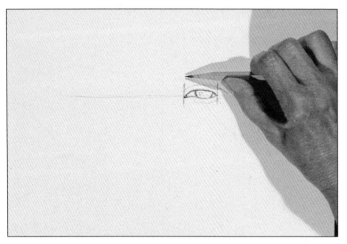

3 | **Continue to Measure and Compare**

Since the eye you have drawn may not be the same size as the one in the photo, measure the eye in your drawing as you did on the photo. Put the corner of the pencil on the inner corner of the eye and place your thumbnail on the pencil at the outer corner. Now, keeping the same measurement on your pencil, measure from the drawn eye to where the other eye will be drawn.

4 | **Draw the Second Eye**

Make a small mark where the eye belongs. Before drawing it, take the same measurement and mark the other corner of the eye. You now know exactly how big the second eye should be. Draw it in being aware that even though eyes are the same width, one seldom looks exactly the same as the other.

You now have both eyes drawn and they are in perfect proportion to the photo. Measure the rest of the face in the same way, comparing everything to the eye measurement.

Tip Keep it light—draw guidelines lightly. All of the guidelines you have drawn will be erased when the drawing is complete. Draw them in lightly to ensure that they can be erased.

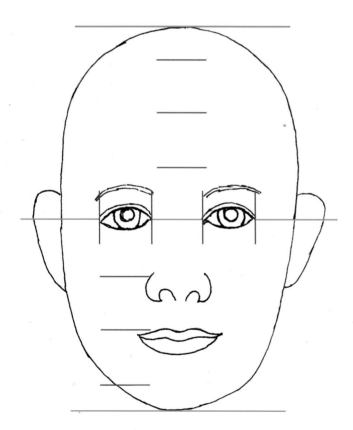

Get the Eyes Right

This illustration shows an average adult face with the eye measurements indicated. Every face differs slightly, but this shows the general dimensions. The eye widths are shown in red. The green lines indicate the top of the head, the halfway point of the head (which is the eye line) and the bottom.

The measurements in the photo are similar to this illustration, except for the width between the eyes. In the photo, there is slightly more than one eye width between the eyes, and in the illustration there is exactly one eye width. Other than that, the measurements are identical.

A child's face differs from an adult's, in that the forehead of a child appears much larger so the eyes are usually located slightly below the halfway point of the face.

By establishing a measuring unit, such as using the eye width, you can then base the rest of the face on this measurement. The entire head is about seven eye widths high, and slightly less than five wide.

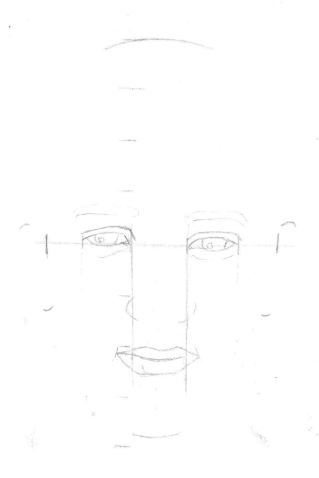

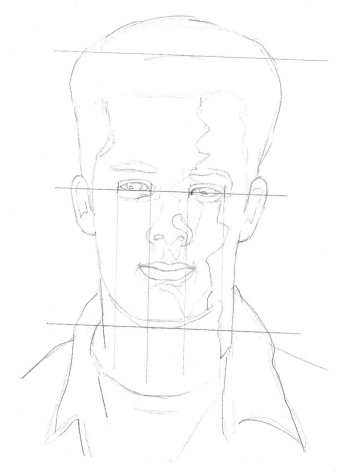

5 | Locate the Nose Shape and the Lips

Draw straight lines down from the corners of the eyes to find out what is directly below them.

You are ready to locate the nose shape. Draw a light line from the inside corner of the eye straight down on the photo to see where it lines up with the nose. The nose appears to be slightly wider than the space between the eyes. Draw in the nose shape.

Using the eye-width unit of measure on the photo, measure down from the top of the nostril to the lip. The lips are wider than the nose and are another eye width down; draw the mouth.

Now measure to find the location of the sides of the head. The width from the outside corner of the eye to the outer line of the face is narrower than one eye width (one eye width would take you out into the ear area). With the measurement of the sides of the face you now have four points: the top, bottom and each side of the head. With this information you can easily sketch in the oval shape of the head.

6 | Finish the Drawing

Once you have the oval drawn, place the ears. The top of the ear is level with the eyebrow and the bottom of the ear is about level with the nostrils. Carefully erase any guidelines you have used to complete the drawing. You have now drawn a perfectly proportioned face!

Keep this drawing; you will use it later for a painting.

Tip Once the eyes are right, the rest of the face will be in perfect proportion.

Focus on Features

The Eyes

- Eyes come in a variety of shapes, but all have a basic football shape.
- Most of the eyeball itself is not visible but is under the eyelids.
- The eyelids cast a shadow on the white of the eye.
- The white of the eye is never pure white.
- You also have to consider the thickness of the lower lid.

The Nose

- Noses consist mostly of overlapping circles.
- This is one area where you really need to draw what you see, not what you think is there.
- The shadows on the nose create the shape and volume.
- The actual shapes of the shadows are more important than the nose shape itself.

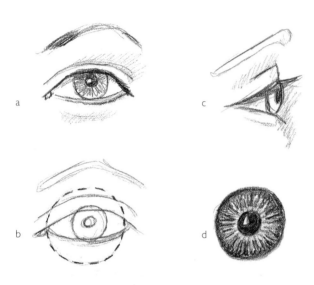

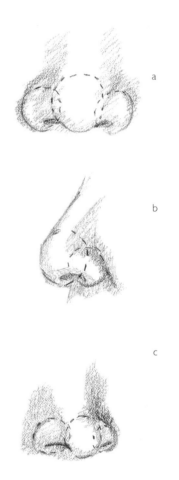

Eyes, Up Close

In the illustration, note the thickness of the lower lid (a). The entire iris is not visible because part of it is covered by the lid.

We only see a small part of the eyeball (b); most of it sits behind the lids and in the bones of the face.

From the side (c), the part of the eyeball that we can see is shaped like a rounded triangle. The inner corner of the eye is no longer visible.

The iris (d) contains the color of the eye (blue, brown, etc.). Because the iris is actually a muscle that contracts around the pupil, it appears to have lines within the color that radiate out from the pupil. The iris is darkest around its outer edge.

Nose, Up Close

The nose from the front (a) appears to be composed of three circles that overlap. The middle circle is the largest. The nostrils appear as small, flat ovals.

The side view (b) varies greatly from face to face. When drawing, compare to the rest of the profile and measure the length of the nose in eye widths.

The three-quarter view of the nose (c) is the same three circles as the front view, but they overlap more on the side that is farthest from the viewer.

More Features

Lips

- The upper lip is usually smaller than the lower lip.
- The muscles in the lips create small bulges in the lips.

Ears

- Drawing ears is just a matter of determining their size and copying the shape you see.
- No two ears are alike, even on one person.
- Size, shape and level vary greatly, so be observant.

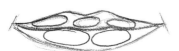 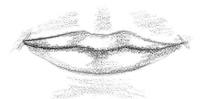 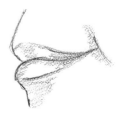

Lips, Up Close

There are three muscles in the upper lip and two in the lower.

By taking this into consideration, you can shape and shade the lips. Be observant and draw the opening line carefully, as this determines the shape of the lips.

Ears, Up Close

Ears are a very funny shape. They can appear shaped like the letter "C" or like a question mark. Make sure to observe where the top and bottom fall in comparison to the rest of the face.

Drawing the Profile

Drawing a profile is a fun way to begin achieving a likeness of someone you know. Profiles are easier to draw since you are only drawing half of the face.

All of your questions are answered by measuring and comparing one shape to another.

Begin the profile the same way you began the front view. The measurements are the same; the eyes are located halfway down the head, so visualize where on your paper you will want the eyes. Draw the shape you see and include the eyelashes as part of the shape. You will then use this measurement to measure the rest of the face. Instead of measuring from corner to corner on the eye, you will measure from the outside corner to the front of the eye (which is all you can actually see).

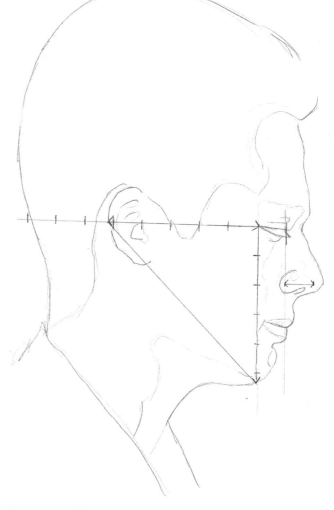

Tips
• A common mistake is to place the ear too close to the eye. Notice that the distance is the same from the corner of the eye to the chin as it is from the corner of the eye to the back of the ear.

• There are three eye widths from the back of the ear to the back of the head.

Measure and Compare

After you draw the eye shape, draw the shapes that surround the eye, indicating the upper and lower eyelid. As you can see from the drawing, the bridge of the nose is less than one eye width from the front of the eye. Place a dot to indicate the bridge of the nose. Draw light lines straight down from the edges of the eyes to determine where the nose and lip shapes belong. The nose is wider than one eye width and measures two eye widths down from the eye. Place dots to indicate these measurements and sketch in the nose. Connect the tip of the nose to the dot for the bridge. Copy the angle of the nose from the photo. Continually ask yourself questions: How far out do the lips extend? Does the chin extend farther than the lips?

Drawing a Three-Quarter View

In a three-quarter view, one eye is totally visible while the other is partially hidden. Notice also that the eye on the right is much wider than the eye on the left.

This view is the most difficult to draw. Do several profiles and front views before you attempt a three-quarter view. The same comparison method is used as for the others.

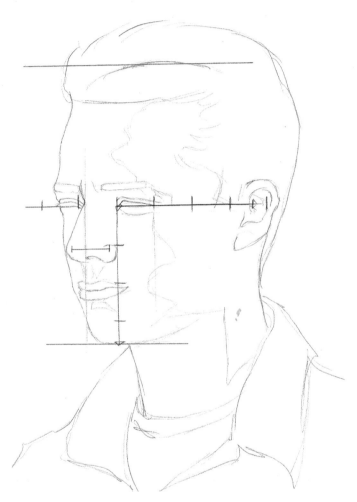

Continue Using What You Have Learned

Draw the eye on the right, which is actually the subject's left eye. Measure that eye, then move your pencil and measure from the inner corner of that eye toward the other eye. You can see from the drawing that there is not a complete eye width between the eyes. Draw the left (partially hidden) eye and place the bridge of the nose.

Draw straight lines down from the inside corners of each eye. This will show you where the nose and lips are located. The outside edge of the nostril is straight down from the inside corner of the eye and begins one eye width down. Put a dot where the nose starts. Notice that the tip of the nose is straight down from the center of the other eye. The nose is a bit wider than one eye width. The top of the nostril is straight down from the bridge of the nose. You now know the length and width of the nose—draw that in.

One more eye width down from the beginning of the nose shape is the upper lip. Note where the corners of the mouth fall compared to the eyes and nose. Sketch in the lips and the chin line. The distance from the bottom of the chin to the corner of the eye is the same distance as from the middle of the ear to the same corner of the eye. The top of the head (not including the hair) to the corner of the eye is the same distance as the chin to the eye. Sketch in the contours of the face, noting that the nose touches the edge of the cheek and the chin is straight down from the nostril.

The neck must be wide enough to support the head. It is about the same width as the measurement from the eye to the chin. Drawing is nothing more than comparing one shape to another.

You have now drawn all three poses.

The Figure

The figure is a fun subject to draw and paint. With watercolor, you can do everything from putting small figures into your paintings to painting detailed figure studies.

The figure is measured in heads. A normal adult is between seven and eight heads high, depending on their height. A short woman may be only seven heads tall, while a tall man may be a little over eight heads.

To measure a figure, use the same technique as you did when measuring the face. With your pencil, measure the head from top to chin. Take that same measurement and determine how many times it repeats in the figure.

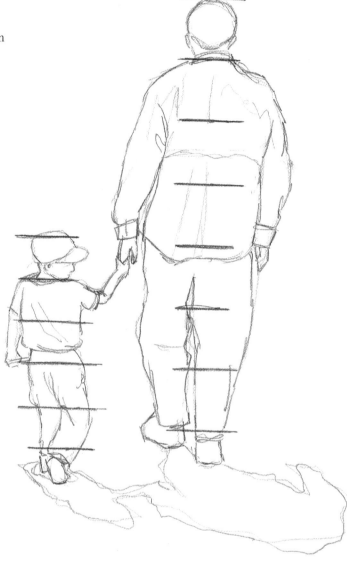

Measure the Head

The little boy in this picture is about five heads high. The man is seven heads high. The younger the child, the larger the head in comparison to the body.

When you see a drawing that is supposed to be an adult but looks like a child, the problem is the size of the head. When drawing adults, make the head a bit smaller than you think it should be. That way, the figure will always look well drawn.

Drawing the Figure

Before beginning to draw, measure and determine how many heads
tall the figure is.

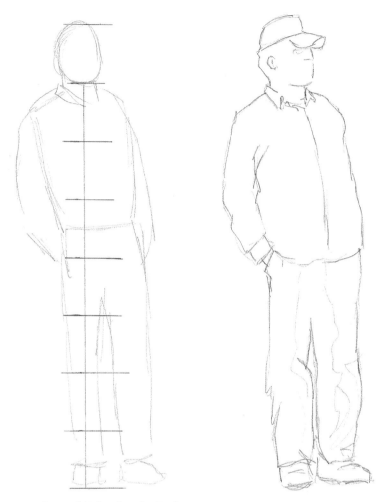

Measuring and Balancing the Body

The entire man in the illustration is eight heads high. With a pencil mark, locate on your paper
where you want the top of the head and the bottom of the feet. Sketch in the head, estimating the
size. Now, before drawing the figure, measure the head you have drawn and make sure you have
room for seven more that same size. If you have estimated the head size wrong, adjust it and
measure again until you have the correct height of eight heads.

 Sketch in the rough shape of the figure, with the waist about three and a half heads down from
the top. In this drawing, everything is measured by the length of the head, unlike the face that was
based on the width of one eye. Once you have the rough drawing, you can add the detail.

 The body must be balanced. Draw a line from the center of the neck down to the foot that bears
the weight of the figure. This man appears to be leaning back slightly, but the figure is balanced
because the line from the neck goes down to the weight-bearing foot.

It's All About Shape

When recreating a face, the shapes of light and dark are the most important thing for you to observe and consider. The shadow shapes make a drawing not only look like a believable person but they also help capture a likeness of that person.

In the photo of Ashriel, you can see three distinct values, or shades, of color. They are dark, light and midtone. Sometimes it is easier to see these shades of value in a black-and-white photo. You can have a color photo reproduced in black and white or use your imagination to remove the color.

We will do a value study of Ashriel, using the white of the paper as the lightest light. The midtone will be gray and the dark will be black.

Linking of Shapes—Shadow and Light

Look at the photo of Ashriel and squint your eyes so that all you can see are large shapes of color. This helps you to see that the shapes in the photo of Ashriel are all linked to each other. By having the shapes linked in the painting, it will lead the viewer from one area of the painting to another. Notice that the white shapes seem to be one large shape that runs along the face from the neck. The black shapes are also (for the most part) linked. The small black shapes of the details are not linked, but are small, so are not as important.

When shapes aren't linked, you can use your imagination to link them. Large shapes work to lead the viewer's eye around the painting. Try to have the dark and light shapes meet at the center of interest. In this photo, the center of interest is around the eyes, the only area where the white and black shapes meet. Notice that in other areas of the value study, there are gray shapes in between the black and white shapes. In the neck area, even though the photo does not show a gray area, by adding gray the area becomes less important, allowing you to direct the viewer back to the center of interest—the eyes—the only place the white and dark shapes meet. In this area the blacks appear blacker than the others, and the whites appear whiter. Without the viewer realizing it, this area will grab their attention first.

Tip When you squint, small details are blurred, making it easier to see the large shapes.

[MATERIALS LIST]

◉ Small piece of illustration board
◉ No. 2 pencil
◉ Gray marker
◉ Black marker

Shadow and Light
Ashriel is a great subject to paint. You can clearly see the shapes of shadow and light in this photo. The dark shape runs all the way from the forehead to the shoulder. The light shape runs from the forehead down the front of the face to the chest.

1 Make a Quick Sketch
Draw Ashriel on a small piece of paper. Don't worry about making this drawing perfect; a quick sketch is fine. When finished, outline the white shape you see in the photo with the gray marker. The gray marker is easier to see than pencil lines.

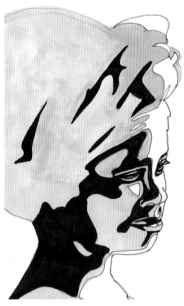

2 | **Color in the Subject**
With the gray marker, color in all of Ashriel except the white outlined shapes.

3 | **Draw the Black Shapes**
Color the darkest shapes you see with black. Notice how the completed value study resembles the photo without any detail. The shapes create the likeness.

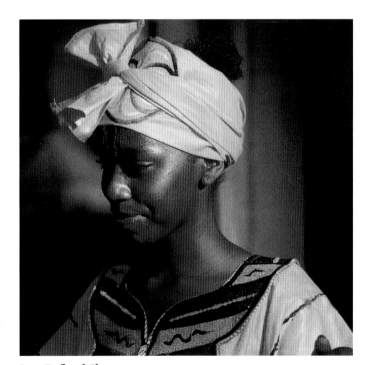

Less Defined Shapes
Amanda is the sister of Ashriel. The shadow and light shapes are not quite as obvious in this photo as are the shapes in Ashriel's photo. You will have to use your imagination to link the white shape from the hat to the shoulder.

Value Study
The shadow shape in this value study is linked down the front of the face to the neck. The dark shape on the face is linked to the hat by adding some darks as shadows. The lights are linked by adding light to the hat and ear to connect to the light on the neck.

Quick Sketch With Color

Using a few basic colors and what you have learned so far, let's paint a quick sketch in color.

Amanda is from a family of thirteen beautiful children. They are all very gracious about letting me paint them, and are quite used to me constantly snapping photographs. Amanda's mother and sister are featured on page 41.

Reference Photo

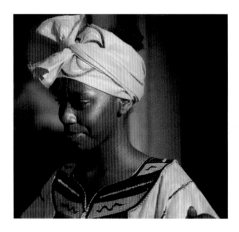

[MATERIALS LIST]

⊚ Small piece of watercolor board, 8" x 10" (20cm x 25cm)

Paints
⊚ Burnt Sienna
⊚ Ultramarine Deep

Brushes
⊚ No. 8 round
⊚ No. 10 round

Other Supplies
⊚ No. 2 pencil
⊚ White eraser (if needed)

 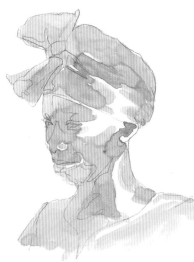 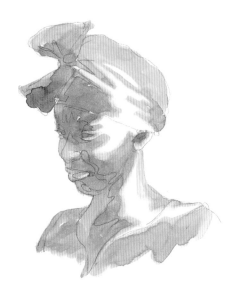

1 | **Begin the Drawing**
Use the no. 2 pencil to draw Amanda. Draw the dark shape, do not draw the light shape (you don't want the pencil lines along the white edge to show later).

2 | **Add Color**
Using your no. 10 round, prepare some Burnt Sienna on the mixing area of your palette. Make the paint a watery puddle (about the consistency of thin milk). Loosely paint in all of Amanda's face, going around the white shape. This does not have to be perfect. Even though the white shape is not drawn, paint around where you picture it to be—the shape does not have to be exactly like the value study.

3 | **Soften Edges and Add Another Layer**
Using a damp no. 8 round, soften all the edges (see page 12, *Softening an Edge*) of the white shape you have created. When dry, add a bit more Burnt Sienna to the light value you have already painted. Leave the edges of the original shape showing—this creates a value between the midtone and the dark.

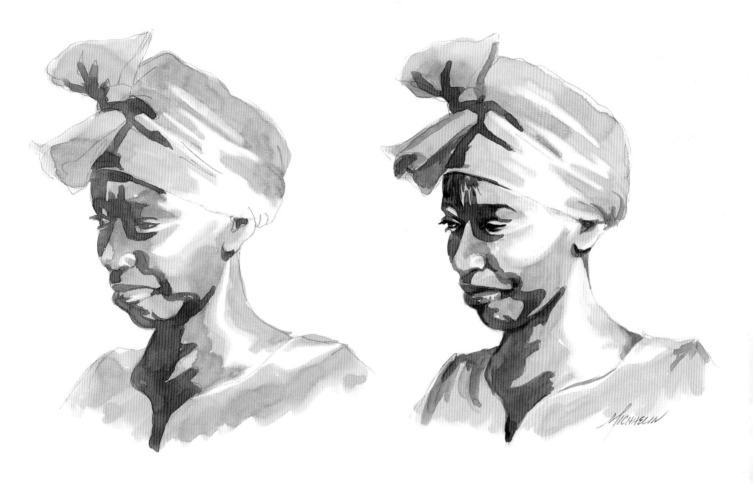

4 | Paint the Dark Shape
Using your no. 8 round and a thicker puddle of Burnt Sienna, paint the dark shape including the irises of the eyes.

5 | Finishing
Still using your no. 8 round, mix a small puddle of thick Burnt Sienna with Ultramarine Deep. This mix should be thick and black, with very little water in it. Using this thick mixture paint in small darks for the details of the eyes, corner of the mouth, hair and any small dark shadows you want to add. This is a loose portrait, so don't spend too much time with detail.

This is the basic technique for painting people. Start with a thin wash to create a large shape, then add smaller and darker shapes, using thicker paint for each layer.

Congratulations, you have completed your first watercolor portrait!

painting
SKIN and HAIR

Mixing color for skin tones is really fun. Depending on the nationality of the subject, skin tones can be anything from light peach, to deep, rich variations of brown. Skin is very reflective of warm or cool light as well as the colors around it, making it even more varied and rich. There is also a big difference between the skin color of children and adults. ✆ It is very important to use transparent colors for your basic skin tone. Skin is very transparent and if you choose opaque colors to paint skin, the person will not look alive—opaque colors tend to deaden the skin. ✆ Establish the color for the undertone of the skin by observing your subject carefully. Does the person have a warm tone to their skin? If so, the undertone is probably yellow. Some people appear very pink and some black skin appears very cool and has an undertone of blue.

Hair, like skin, comes in many colors and textures and has a variety of undertones. Both blond and black hair have cool or warm undertones. Light influences the colors greatly; the same hair looks very different on a sunny day than on a cloudy one. ✆ Hair can be thin or thick, straight or curly, and your brush stroke must vary to show these qualities.

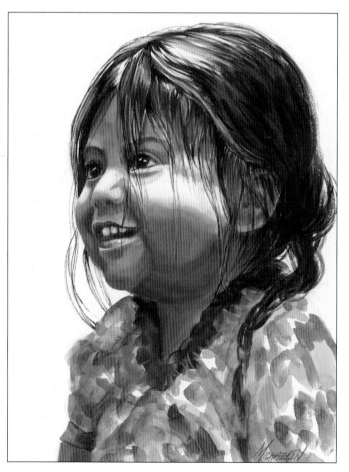

Using a Raw Sienna Undertone
Sahrita is from Antigua, Guatemala. Her whole family models for my biannual watercolor workshop there. The undertone color used for her Mayan skin is Raw Sienna. Carmine and Burnt Sienna were then added for the skin tone. Shadows of Ultramarine Deep mixed with Burnt Sienna were added last. A step-by-step demonstration of this painting appears in chapter 5 (page 71).

SAHRITA • 10" x 14" (25cm x 36cm) •
Collection of the artist

Caucasian and Black Skin

Caucasian Skin

Adult Caucasian skin is not quite as fresh and clear as children's skin, and frequently appears slightly yellow. For this reason, Raw Sienna and Carmine make a great adult skin tone mixture. Burnt Sienna added to the basic skin mixture is used for shadows. For the darkest shading, Ultramarine Deep is added to the Burnt Sienna to make a very dark brown. Use this sparingly, as too much dark can be very distracting.

Black Skin

The darker the skin, the more fun it becomes for the lover of color. Darker skin is much more reflective than light skin. Probably the most exciting skin color to paint is black skin. The undertones can vary greatly, as well as the values. One person's skin may be very dark, while another's may be very light. You must be observant and try to establish the undertone first. When the undertones are cool, begin the painting with Cerulean Blue; when the undertones are warm, begin with either Raw Sienna or Burnt Sienna, depending on the darkness of the skin. The basic warm skin tone color is usually Burnt Sienna. The basic cool skin tone color is Burnt Sienna mixed with Ultramarine Deep. Mixing Burnt Sienna with Ultramarine Deep removes some of the warm orange tone from the Burnt Sienna.

No matter what the undertone, the shadows are painted with a mixture of Burnt Sienna and Ultramarine Deep. Because black skin is the most reflective of all, you can add lots of arbitrary colors after your shading is done.

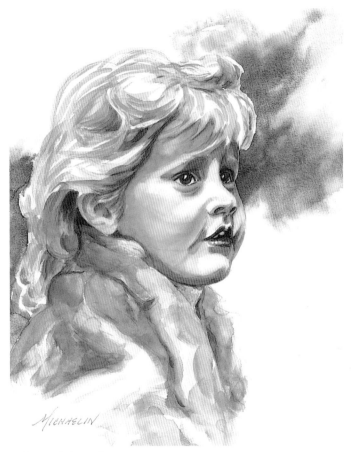

Using a Pink Undertone
The undertone of this portrait is pink. Aureolin and Permanent Red were used for the basic mixture, with Burnt Sienna added to the mixture for the shadows. Ultramarine Deep was added last for the shadow areas.

APRIL • 10" x 14" (25cm x 36cm) • Collection of Mr. and Mrs T. Berry

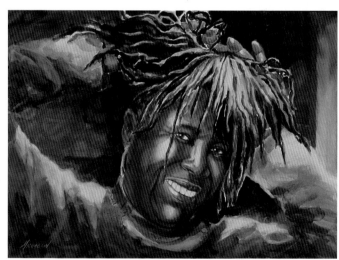

Using a Warm Undertone for Black Skin
Flo's Hair is a playful portrait using a warm undertone for the black skin. Flo is full of fun and personality, so the red and yellow were added to the hair and skin to help show this playful quality. The skin was started with Burnt Sienna and shaded with Burnt Sienna mixed with Ultramarine Deep before the arbitrary colors were added for the final layer.

FLO'S HAIR • 30" x 40" (76cm x 102cm) • Collection of F. Baldie

Latin, Asian and Middle Eastern Skin

Latin Skin

Most Latin skin has a warm undertone. The basic mixture is Raw Sienna and Burnt Sienna; if there is any hint of pink, a touch of Carmine can be added, especially to the cheeks. The second wash of color is Burnt Sienna with a touch of Carmine, getting darker for the shadows. Leave some of the Raw Sienna showing. For the darkest shadows, use the Ultramarine Deep and Burnt Sienna mixture.

Latin children have the same basic coloration as Latin adults, with perhaps a bit more pink.

Asian Skin

Most Asian skin is quite light, but it can vary. It is usually pale, slightly transparent and has a yellow undertone. Start with Raw Sienna and shade with pale Burnt Sienna. Add a touch of Carmine to the rosy area of the cheek. It is always necessary to be observant, as light and surrounding color can make skin tones vary significantly.

Middle Eastern Skin

Many Middle Eastern people have a slightly green undertone to their skin; however, if you start out with green, you will not get a believable skin tone. Start out as if you are painting Latin skin, with Burnt Sienna, Raw Sienna, and a small amount of Carmine. After the shading is complete, wash over some areas with a very diluted Sap Green to achieve an olive tone.

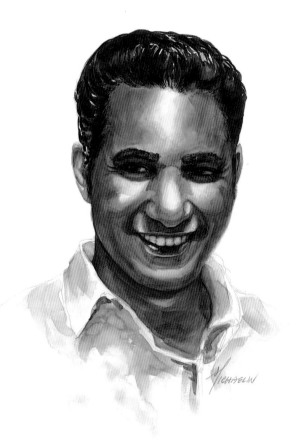

Begin with Raw Sienna

Kamil is from the Middle East. He has quite a yellow/green undertone to his skin. This watercolor sketch was started with Raw Sienna. The second layer was Burnt Sienna, Raw Sienna and a bit of Carmine. Each layer was allowed to dry before a thicker mixture of the same colors was applied. Areas were then glazed with diluted Sap Green to create an olive tone (this is evident on the forehead and under the eyes).

KAMIL • 10" x 14" (25cm x 36cm) • Collection of Cheryl Sievert

Arbitrary Colors in Human Skin

Because of the wonderful reflective quality of human skin, it reflects surrounding colors. If you look closely at the bottom of someone's chin, you will see the color of their shirt reflected there. The darker the skin, the more reflective it appears to be. Black skin is very reflective and will even reflect colors that are a distance away.

As stated earlier, arbitrary colors are colors that would normally not appear in skin but are put there to make the painting more dramatic and colorful. These colors add vibrancy to a portrait and, I feel, also add a spark of life. The color can also be used to convey the personality of the subject.

Many times, there are areas of a painting that appear cool, even though the skin color has a warm undertone. For example, the temple area, and the area under the eyes, are very vascular so they often appear blue. The corners of the mouth are other areas that often appear cool. By putting some blue in the corners of the mouth, you actually push the corners in and add dimension. The inner corners of the eyes are the same and should have a touch of blue.

Any blue can be used for this. In the example on this page, the blue I used was Turquoise Blue, since that was the blue I used in the background. An opaque color will show up better on top of the skin tone. There is more Turquoise Blue on the back of the neck reflecting the color from the wall behind. You can use any color you wish for this—a bright yellow is a fun color. Don't feel it has to make sense; just have fun!

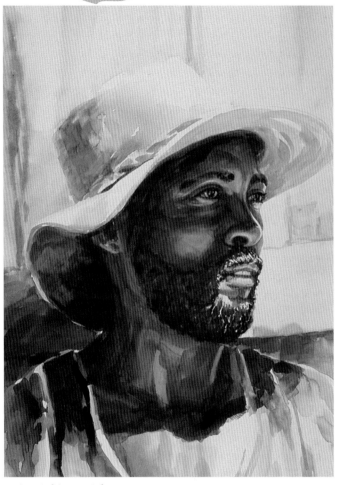

Using Arbitrary Colors
Opaque arbitrary colors were used in this painting. Opaque Turquoise Blue was applied to the eye area, neck, and in the beard. Carmine, applied very thickly, worked for the red in the cheeks. Even though Carmine is a transparent color, used in a dark value it shows on top of the skin tone. Remember to apply these colors last so you do not make the skin appear muddy. Once these colors are added, do not add skin tone on top.

JOMO • 18" x 24" (46cm x 61cm) • Collection of the artist

Tip Have fun! Arbitrary colors can be fun—you can use any color you wish to brighten up a portrait!

Hair Color Mixtures—Black Hair

Hair can be really exciting to paint. Like black skin, black hair reflects the colors around it. Use your imagination and bring in colors that appear in other parts of the painting (arbitrary colors). Don't be afraid to exaggerate the color; remember, this is a painting, not a photograph.

The method illustrated on these two pages is the method I use to paint all hair. To create the hair color you desire, just switch colors as needed. Following are some of my favorite color mixtures for all types of hair. Try them yourself!

[MATERIALS LIST]

⊚ Small piece of illustration board

Paints
⊚ Cerulean Blue ⊚ Burnt Sienna
⊚ Ultramarine Deep

Brushes
⊚ No. 4 round ⊚ No. 12 round
⊚ ¼-inch (6mm) flat

Other Supplies
⊚ No. 2 pencil ⊚ White eraser

1 | Paint the Highlights

For this exercise, we are imagining a swatch of hair. Draw the shape lightly in pencil so you have a guide for the direction of the hair. Using the no. 12 Cerulean Blue, going in the direction of the hair. These strokes will be part of the highlight in the hair. Let dry. Using the same brush, apply some Burnt Sienna in the same manner. Let dry. Highlights can be any color; using colors instead of just white for highlights gives more dimension to the hair.

2 | Add the Hair Color

In the mixing area of your palette, bring out a very thick puddle of Ultramarine Deep. Without rinsing your brush, go right into the well of Burnt Sienna and bring some out to the mixing area, to add to the blue. By not rinsing your brush, you will keep the mixture much thicker and make a dark black.

Using this dark black mixture, with the no. 12 round, stroke in dark black in the direction of the hair. Allow the white of the paper to show, as well as some of the blue and brown. Let dry.

3 | Final Details

With the very tip of the no. 4 round, pick up some of the dark black and stroke in some stray hairs. A few wisps of hair will make the hair look more natural.

If desired, you can soften the edges of the highlights. Wet your small ¼-inch (6mm) flat and dab off excess water on a paper towel. Run a damp brush along the edges that you wish to soften. Rinse the brush often, as you will be picking up paint each time you run the damp brush along an edge. Always remember to dab off the excess water onto a paper towel after you rinse the brush. The brush should be damp, not wet.

You may wish to leave the high-lights more crisp, as they appear in the middle illustration above. If so, do not soften any edges. If you decide to soften, leave a few crisp edges for variety.

Tip To get a rich dark, it's important to use as little water as possible. Rinsing your brush out each time you get another color will keep adding more water to the mixture, which dilutes the color.

Blond Hair

Blond hair is probably the easiest to paint. Here is my favorite color mixture for blond hair. Always begin with the lightest color in the hair.

[MATERIALS LIST]

⑥ Small piece of illustration board

Paints

⑥ Raw Sienna ⑥ Burnt Sienna

⑥ Ultramarine Deep

Brushes

⑥ No. 4 round ⑥ No. 12 round

⑥ ¼-inch (6mm) flat

1 | Paint the Highlights
The lightest color for blond is Raw Sienna, because Raw Sienna is a slightly grayed yellow and is a more natural color for hair than a bright yellow. Use the no. 12 round and apply the strokes in the direction of the hair. Try to paint shapes rather than strokes which are all the same length and width. Let the colors dry in between layers.

2 | Add the Next Color
Use the same brush to apply the next darkest color, Burnt Sienna. Add additional colors sparingly; go slowly and think about each stroke. Leave large white shapes.

3 | Final Details
Finally, add some dark brown: Burnt Sienna mixed with Ultramarine Deep. Use the dark sparingly—leave the majority of the hair Raw Sienna. Add a few stray hairs using Raw Sienna and the no. 4 round, then soften with your small ¼-inch (6mm) flat and water (as you did in the last step for painting black hair).

Other Hair Colors

Hair can be a variety of colors. Look for the base color and begin with that color, then add slightly darker colors.

Gray or white hair has a base color of either yellow (warm) or blue (cool), depending on the quality of the light surrounding the subject. On a bright, sunny day hair will appear warmer than it will in artificial, cool light. The base color for gray or white hair can be either Raw Sienna (warm) or Ultramarine Deep (cool). Use this base color very sparingly, especially if the hair is more white than gray. Look for shadows and highlights in the hair. Leave the white of the paper as the highlights and paint the shadows with color.

Brown and red hair always includes Burnt Sienna. If brown hair appears to have blonde highlights, start with a base of Raw Sienna. Red hair can appear coppery or more pink. To achieve a pinker look, start with Burnt Sienna and add Carmine if needed. To mix a more coppery red, start with Raw Sienna, then add Burnt Sienna mixed with Carmine. Be flexible and experiment.

Hair Swatch Examples

These examples of hair swatches show mixtures for gray, brown and red hair.

For gray hair, start with either Ultramarine Deep or Raw Sienna, depending on whether the hair appears warm or cool. Brown and red hair always includes Burnt Sienna. Add some Carmine to the mixture if the hair appears pink.

No matter what color of hair you are painting, a mixture of Burnt Sienna and Ultramarine Deep is always a good choice for the darkest colors. Soften some edges with a damp brush if desired.

WHITE OR GRAY HAIR

Ultramarine Deep (cool) base color with thinned mixture of Burnt Sienna and Ultramarine Deep.

Raw Sienna (warm) base color with thinned mixture of Burnt Sienna and Ultramarine Deep.

BROWN HAIR

Base color of Raw Sienna (warm) with Burnt Sienna added on top. If hair is darker, add a layer of Burnt Sienna mixed with a touch of Ultramarine Deep.

Start a cool dark brown with Ultramarine Deep, then add the Burnt Sienna and use a mixture of Burnt Sienna and Ultramarine Deep for darks.

RED HAIR

For the pinker tone, start with Burnt Sienna and add Carmine.

The coppery tone is achieved by starting with Raw Sienna as a base, then adding a mixture of Burnt Sienna and Carmine.

Textures of Hair

When painting hair, brushstroke is important. The amount of curl and the length of the hair are determined by your brushstroke.

Create short, curvy strokes of curly hair (a) using a no. 12 round. By simply adding highlights and shadows, these strokes will appear as actual curls.

Long, wavy hair (b) is painted with long, wavy strokes. Again, adding shadows and highlights adds to the wavy illusion.

Paint very curly hair (c) with strokes that appear to be scribbles. Extremely curly hair does not usually have many highlights; it appears less shiny than straighter hair.

The reason is that curly hair does not clump together like straight hair—the highlights are on each hair individually, making the highlights less visible to the eye. Try to make a variety of shapes rather than strokes of all the same length and width.

Look at three of the paintings shown earlier in this chapter. *April*, on page 31, the blond, wavy hair is reflecting some pink from the clothing, *Sahrita*, on page 30, has both warm (Burnt Sienna) and cool (Cerulean Blue) in her long, slightly wavy hair. The hair appears very baby fine with the addition of long, thin stray hairs. And *Jomo*, on page 33, has a very short and curly beard—notice the curved, short strokes used to convey the tightly curled hair.

a

b

c

Brushstroke Determines Texture
The size and direction of your brushstroke will determine the texture of the hair. Because the brushstrokes should always go in the same direction the hair is going, you can make the hair as curly or straight as you want. Likewise, the length of your stroke will determine the length of the hair. A short, curly stroke will look like short, curly hair. A long, wavy stroke will look like long, wavy hair.

working from PHOTOS

Nothing can replace sketching and painting from a live model. However, that is often not possible or may be inconvenient. Working from photos can give you more time to draw and paint, especially if working with children. It's very important to try and take your own photos, which will give you the opportunity to interact with the model and control the lighting. You will find that you can get to know a person's characteristics quite well by shooting a roll of film. ✆ Unposed photos are usually much more interesting than posed portraits. They require more time and film but are usually worth the extra effort and expense. ✆ *Take pictures first, ask questions later* is my motto. If you think you got a great picture that would make a good painting, find the person you have photographed and ask permission. If you ask permission first, the person will pose and look stiff. People are generally very flattered to be asked. ✆ While out taking pictures, it is usually obvious if someone absolutely does not want their picture taken. If that is the case, I just turn and take a picture of someone else. But I've found that most people don't mind at all.

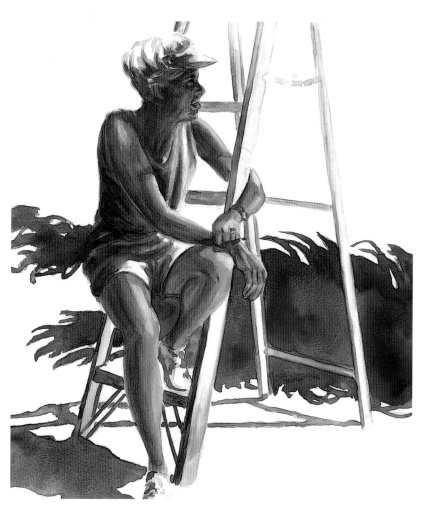

JUNE • 15" x 20" (38cm x 51cm) •
Collection of Mr. and Mrs. D. Rott

Choosing the Right Photo

Whenever possible, have more than one photo to choose from. Use your camera to help you with the composition. In the examples here, Cleo looks lovely in both pictures. However, the second picture makes a much better composition. In the first photo, the arms go straight across, making an unattractive shape that appears repetitive. Also, the right arm forms an awkward shape, coming out toward the camera. This would be difficult to paint convincingly.

Also, in the first picture, the negative shapes (the shapes in the background made by the arms and head) are the same on both the right and left, top sections, of the picture. Compare to the second picture; with the arms at a different angle, the shapes in the background become more interesting and are different sizes. The right arm is now in a position that will be easier to convey. The overall feeling of this picture is more graceful.

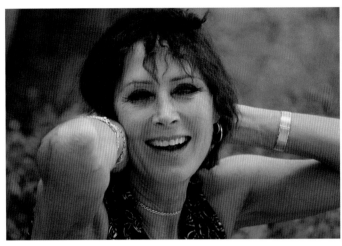

An Awkward Composition
Cleo looks lovely in both photographs, but this photo appears to have a straight line from one elbow to the other. The shape the right arm creates is not attractive and looks very large because of the way it comes forward.

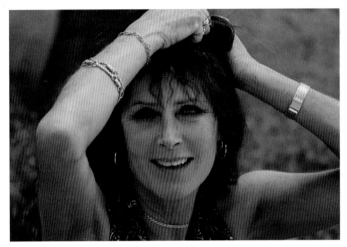

A Much More Interesting Composition
This photo has much better symmetry. She looks more graceful, and the negative shapes created in the background are now all different sizes and much more interesting.

Tips • Take lots of pictures. Busy marketplaces, gatherings, even city streets make good material for paintings.

• If you get a great picture and can't find the model, just paint the picture and change the model. Change the hair color, clothing, or some other feature; it is not hard to make the model look like someone else.

• If you plan to print or publish the painting, you do need to get written permission.

Compositional Considerations

There are whole books written about composition. Because this book focuses on painting, there is not enough space to include adequate material on all elements of composition. To simplify, remember to use large shapes and try to convey a message.

Ask yourself a few questions:

- What message or emotion am I trying to portray with this painting?
- How much is important to that message?
- Are the shapes in the background all the same size and shape, or are they varied?

Background Shapes

Look at the painting *Sisters*. The original photo only included the center and left figures. The figure on the right was added in the foreground to make three figures instead of only two—odd numbers always work well. Also, adding the additional figure made the negative background shapes more interesting and more varied. The closer, foreground figure also adds more depth.

The dark shape in this composition is just as important as the light shapes. Whenever possible, try and combine shapes into large ones instead of a lot of small shapes. These shapes can run from the figure into the background (and still be considered one shape) or be contained in the subject. In this example, all of the shapes are contained within the figures; they even run from one figure into another. The reason this works in this painting is because of the different sizes of the background shapes (the white, negative shapes). They are all different sizes, making the shapes contained within the figures more interesting. The dark shapes within the figures are also varied and interesting.

By using large shapes and varying the sizes of those shapes, you will be able to create a good composition.

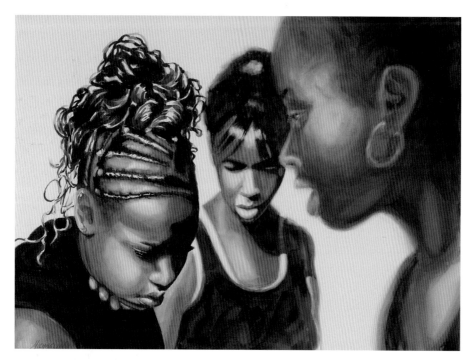

Link Shapes for a Strong Composition
The dark shape within the left figure is linked to the hair and face and continues into the blouse of the center figure. The dark shape continues into the face and hair of the center figure. This gives a very abstract feel to the painting and makes it a stronger composition. Notice that the white shape in the background runs right into the center figure, which helps to link her to the background.

SISTERS • 22" x 28" (56cm x 71cm) •
Collection of the artist

Cropping

You do not need to take a perfect photo. Because you can rearrange things in the painting or eliminate unnecessary objects, you are always free to change whatever you wish. Cropping the photo or zooming in on the subject often creates a better composition. Stephanie and her darling daughter, Ajah, make a great composition. However, eliminating some of the background creates a much more personal and intimate painting.

The Right Light

Try to shoot your photos outside with the sun shining. The shadows created make a big difference in getting a likeness. It may surprise you, but the shape of the shadows helps to create a likeness far more than do the individual features. If you have good light and dark shapes in the face or figure, it will be much easier for you to paint. When you draw the picture, make sure to include lines indicating the dark and light shapes.

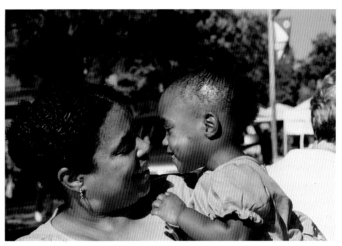

Decide What is Important for the Composition
In this photo used for *Stephanie and Ajah*, the background is not as important as the relationship of the mother and daughter. The people in the background are not important to the composition nor do they add to the feeling the pose conveys.

In *Jim*, the great light is what makes the painting. We will paint this portrait in chapter 4. The light and dark shapes in the face make the likeness.

JIM • 12" x 15" (30cm x 38cm) •
Collection of the artist

Crop to the Center of Interest
By cropping the photo and moving in closer to the subject, the facial expressions become much more important. Letting the mother's head go off the page focuses more on the baby, making her the center of interest. The resulting portrait, speaks more about their feelings and less about their surroundings.

STEPHANIE AND AJAH • 12" x 15" (30cm x 38cm) •
Collection of Mr. and Mrs. Adrian Walker

Valuable Background Decisions

I usually do a value study before I start a painting. A value study can give you a blueprint to follow when painting and will actually take the fear out of starting your painting. Begin with a quick sketch on scratch paper. Don't worry about making it detailed, just get the basic shapes. Using only three values, white (the paper), gray, and black, fill in the shapes in your sketch. Prismacolor markers work very well for this, but you can use watercolor or even pencil to do your sketch and value study. Try and have as few shapes as possible. Where you can, link shapes together, even running the shape from the figure into the background.

After I have planned the painting using the value study, I will often paint the background before I start the figures. The figures take a lot of time, and if I'm not happy with the background, I would rather start over before I have spent hours on the figures or faces. I have redone a background as many as four times to get one I really love. So I take the fear out of wrecking a painting by doing the part first that may not turn out.

Learn From Value Studies

When designing the background for *Cleo*, I started by making a quick sketch of the painting as it is. I filled in the shapes with markers, using the gray for the midtones, black for the darks, leaving the paper white for the light shapes.

I tried two different backgrounds. In the first example, I filled in the background with a light gray to see what would happen if I used a solid light color for the background. It looks okay, but not very exciting.

In the second example, I created a black shape that runs behind the figure from one side of the picture to the other and down to the bottom, connecting the dark shape to the sides of the painting. In the first example, the darks are isolated in the center.

The second example also seems to draw more attention to the white shapes of the arms and face. It also links the white area of one arm to the background, which makes the figure appear to be part of the picture rather than just a shape glued onto the background.

Know When to Stop

Blue was chosen for the background color for *Cleo*. Blue works for this painting as it repeats the color of her eyes and dress. The background shape is from the second value study. Even though the shape did not get as dark as originally intended, it seemed to work, so I stopped adding color into the wet-into-wet shape.

CLEO • 13" x 17" (33cm x 43cm) • Collection of E. C. Davidson

Designing More Than a Portrait

My goals, when painting a figure or a portrait, are twofold. First and foremost, I want a good painting; the likeness of the figures to reality is secondary. Even when doing a commissioned portrait, I want the painting to appeal to someone who doesn't know the person or people in the painting.

My second goal is to have the portrait capture the essence of the subject. In other words, I try to add some personality into the painting.

Look back at the painting, *Flo's Hair* on page 31. Using a fun pose and adding lots of bright colors into both her hair and the background helps to convey Flo's sparkling, vivacious personality.

Telling A Story

Body language goes a long way in telling a story in your paintings. A relaxed, natural pose will say far more than a staged portrait. If you are doing a more formal portrait, try to put things in the background that relate to the subject. For the painting *Red Hat Society*, I combined several photos to make the composition. The body positions and expressions on the faces make you feel that a great joke is being told. A café sign behind them places them in a public place.

Hopefully a painting such as this one will make you think about the people: What are they doing? What are they saying? Do they know each other or have they just met? What do the red hats mean?

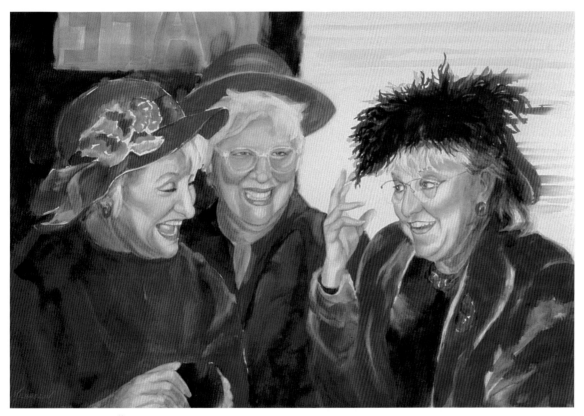

Your Painting Can Tell a Story
This painting tells a story about a club of women that get together solely for the purpose of having fun. From their actions, we must be missing out on a great joke. Their facial expressions and body language convey relaxation and playful talk. Setting them in a café adds to the story. By telling a story, the painting becomes more than a portrait.

RED HAT SOCIETY • 22" x 30" (56cm x 76cm) • Private collection

Poses

Different poses are introduced in the step-by-step demonstrations throughout the book. Several are portraits, while a few are the full figure. When choosing a pose to paint, try and choose one that looks relaxed and natural.

Working from candid photographs usually works much better than working from a posed photo. However, for a commissioned portrait or a study of a face, it is sometimes necessary to work from a posed portrait. Taking your own photographs is recommended; you can get a more relaxed pose and have more control over the setting. Even for a commissioned portrait, I like to try and paint more than just a head in the middle of the paper.

Decide what you are trying to convey with this painting. Are you saying something about the person, or is the message more about what the person is doing? These questions will help you determine how to pose the person.

Posing a model can sometimes be unnerving for both model and photographer. Try and make the setting as casual as possible and wait for the model to relax before snapping any photos. Depending on the position, you can choose to have the model looking directly at you or looking off in another direction.

Candid photographs are really fun to work from when painting the whole figure. The photographs shown on these two pages are of children, and they show the importance of the pose.

One item to be careful of when selecting a pose is to make sure the person looks natural. Some poses can appear off-balance. If the figure looks off-balance, the painting will not work. Even though the human body can balance in some strange ways, it is difficult to convincingly portray an unbalanced figure in a painting. As with Cleo's arms on page 42, if it looks awkward in the photo, the painting will tend to magnify that effect.

The two photos shown on page 45 are of a brother and sister in the pool. The first one is posed and looks a bit unnatural. The next was taken a few seconds later, when temptation got the better of the brother, he just couldn't resist shoving his sister into the water. This second photo shows much more about their personalities than the first one. It looks like much more fun to paint.

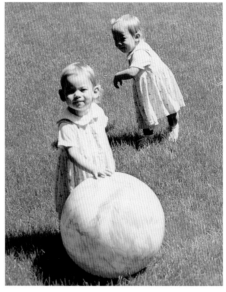

A Pose Should be Natural and Balanced
The photo of the twins illustrates the importance of a pose being natural and balanced. While this is a fun photograph of darling twins, it would not make a good painting as it is. The girl in front is balanced on both feet, even though you cannot actually see her feet. The girl in the back, however, has just lost her balance and looks very awkward. A painting of her in this position would look very unbalanced. The viewer would always be expecting her to tip over.

A Balanced Pose
Even though this young girl is standing on one leg, she is properly balanced and the photo is a good choice to use for a painting (see page 81 for step-by-step painting instructions).

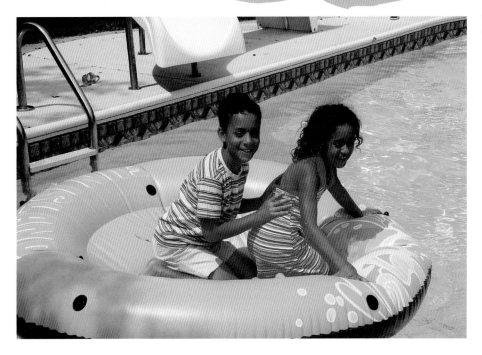

This posed photo is a cute picture of siblings but looks a little stiff and doesn't appear playful.

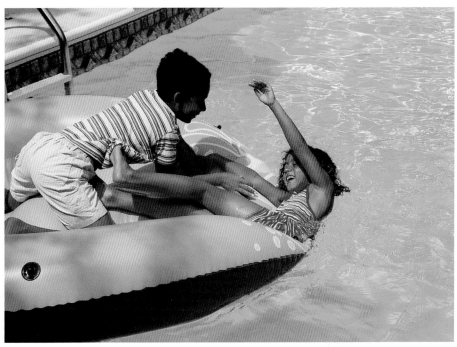

Taken just a few seconds later, this photo really shows the playful sibling rivalry between these two. A painting of this photo would really reflect their relationship and tell more of a story about them.

painting
ADULTS

The next two chapters include step-by-step demonstrations of painting people. You will paint both
figures and portraits. This chapter will focus on adults, as they are easier to paint and draw than children. When
starting a portrait, apply a diluted wash over the entire face, including the eyes and teeth, if they are visible. The only
part that should be left white are the lightest highlights on the face. These highlights are usually on the end of the
nose, in the lips, in the eyes and on the lightest part of the cheek. By applying this very light color over the teeth
and eyes, they will appear much more natural.

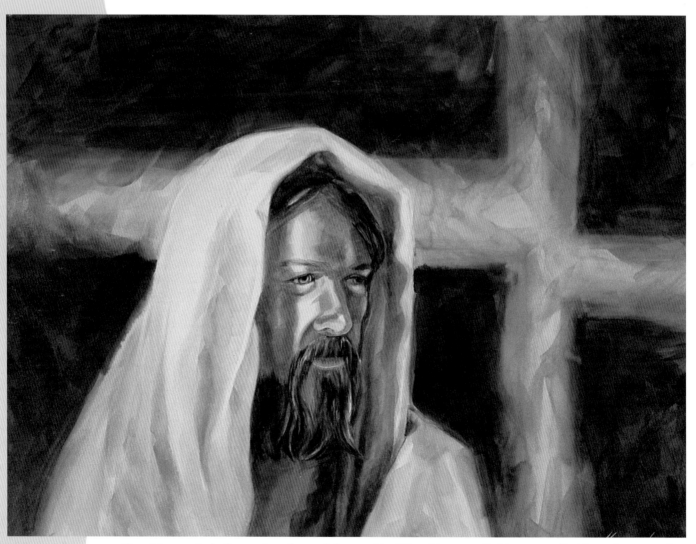

The white areas in the face are the only areas left pure white. When this man walked into my studio, I knew that I wanted to paint him as Jesus. He was very sweet about posing for me.

THE MAN FROM GALILEE • 22" x 30" (56cm x 76cm) • Private collection

Front-Facing Portrait

Use the drawing you completed of Jim from chapter one. There are five values in this portrait, which you will paint in layers. The five values are white (of the paper), light flesh tone, darker flesh tone, darkest flesh tone and the shadow tone.

See page 17 for reference photo.

Tips • When dry, the paper should feel room temperature, not cool, to the touch.

• Watercolor board dries more quickly than watercolor paper.

[MATERIALS LIST]

⑥ Small piece of watercolor board, 10" x 14" (25cm x 36cm)
 (Use your drawing of Jim from chapter one.)

Paint
 ⑥ Raw Sienna
 ⑥ Burnt Sienna

 ⑥ Carmine
 ⑥ Ultramarine Deep

Brushes
 ⑥ No. 4 round
 ⑥ No. 8 round
 ⑥ No. 10 round

 ⑥ ¼-inch (6mm) flat or filbert
 ⑥ ¼-inch (6mm) filbert
 ⑥ 1-inch (25mm) flat

Other Supplies
 ⑥ Water container

 ⑥ White paper towels or tissues

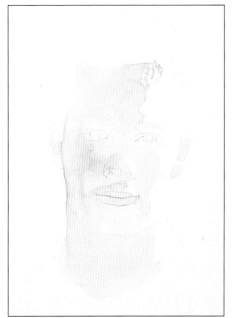

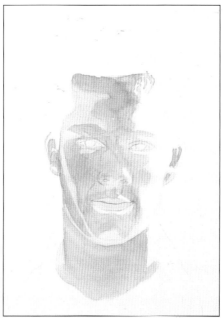

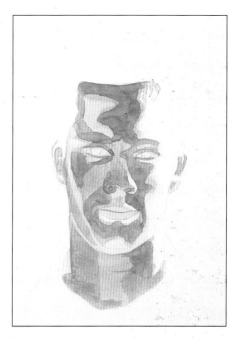

1 | **Begin With the Light Flesh Tone**
Use your no. 10 round and on your palette mix a large watery puddle of a light flesh tone using Raw Sienna and Carmine (this should be pinkish).

Wash the light mixture over all of the areas in the face except for the areas that will be left white. Paint right over the eyes, as the white of the eye is seldom perfectly white. Leave the white highlights in the center of the pupils. Leave a white area on the side of the nose and above and below the lips (this will be smoothed later).

There are now two values, white and the light flesh tone. Allow to dry.

2 | **Add the Third and Fourth Values**
Apply the third value, the dark flesh tone. Bring out the same mixture (step 1) into your palette, with a little less water. Using the same no. 10 round, paint the next layer covering everything except the white and the light areas. Each layer will get darker as the layers build. Leave the light shape on the left of the face, this shape is connected and runs down the side of the face to the chin.

You now have three values on your painting. Allow to dry completely.

With a no. 8 round, mix a darker tone of Raw Sienna and Carmine. Add a touch of Burnt Sienna to darken the mixture even more. Paint the smaller, darker shape directly on dry paper. Again, don't worry about softening any edges, we will do that in the next step. You are now leaving three values showing and painting the fourth value.

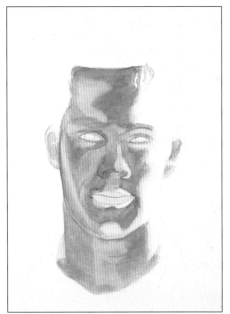

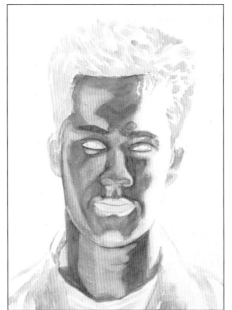

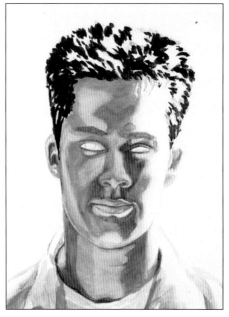

3 | Smooth and Soften

Smooth out the uneven layers. With your no. 10 round make a watery puddle of Raw Sienna on your palette. Stroke the Raw Sienna over all areas except the white of the eyes and the lips. Use a very light stroke. You'll soon know just how much pressure to use for this light glaze. Use this light wash to smooth out the colors, soften edges and make a more realistic skin tone.

Use your ¼-inch (6mm) flat and clean water to soften the edges that border the white areas. Dip the brush into water, dab on a paper towel and gently run the brush along the edge where the white and the skin tone meet. You will pick up color in your brush, so rinse it often, always dabbing off the excess water—too much water will remove too much of the paint. Allow this softened edge to dry completely.

4 | Add the Darkest Value to the Face

With the no. 8 round, mix up the final or fifth skin tone value. Use another mixture of Raw Sienna, Carmine, and Burnt Sienna with even less water, to make a thick mix. Paint each of the small dark shapes, then use a damp brush to carefully soften the edges of the shapes while they are still wet.

Use your 1-inch (25mm) flat to apply the first layer on the hair. You can create a variety of interesting shapes using a flat brush. Paint the first layer of hair with Raw Sienna. Leave lots of white spaces, which will add sparkle to the sunlit hair.

Using the same 1-inch (25mm) flat, paint the shapes of the shirt with a light mixture of Ultramarine Deep. Leave the white of the paper to portray the light areas. Let dry.

5 | Add the Darkest Shapes

With the no. 8 round, mix Burnt Sienna with Ultramarine Deep. Use very little water, just enough to get the paint from the well to the mixing area. This should look almost black and will be the color for the darkest areas of the painting.

Start with the hair. Use the no. 8 round to paint over most of the Raw Sienna in the hair. Leave some of the Raw Sienna showing for highlights in the dark hair. Paint the shadows on the neck that are caused by the shirt.

Use pure Ultramarine Deep to add a few darker shapes into the shirt using the 1-inch (25mm) flat.

Apply a light watery wash of pure Carmine over the lips. While still wet, add the darker areas of the lips with a thicker mix of Carmine. Allow to dry completely.

Tips

• By painting with a very light touch, you will not disturb the first layer. However, if you go over the same spot again and again, you will lift some of the first color and will end up with a light spot. If this happens, let the area dry and wash over it again to smooth it out.

• Remember, the shapes of the light and dark values create the likeness—not the actual features.

6 **Paint the Eyes and Add the Details**

Paint the iris area with Ultramarine Deep, leaving a white highlight. After the blue has dried, use a mixture of Ultramarine Deep and Burnt Sienna to paint the pupil. Paint a black edge of the same color along the edges of the eyes to form the lashes. Don't paint individual lashes, just a shape to indicate them. Allow to dry. Take a no. 4 round and carefully use water to soften the edges of this line into the white of the eyes to make it look more natural.

Use the no. 4 round to paint the final details. Add a dark line in the crease above the eye and allow to dry, then soften. Add dark to the eyebrow and while the paint is still wet, soften.

Add the Lips and Dark Shapes

Finish the lips with Carmine. Add a darker value of thick Carmine to the left side of the lips. Soften while wet and allow to dry. Use a dark mixture of Ultramarine Deep and Burnt Sienna for the rest of the darks. Use this mixture and your smallest brush to paint the line between the lips. Let dry and soften if necessary. Add a touch of the same mixture to the corners of the mouth and soften while wet. This will push the corners of the mouth back to give contour to the lips. Paint in the nostrils with the same mixture and soften while wet. You can also add some small dark shapes to the ear on the right, (the shadowed side of the head). The left ear does not need any darker shapes since it is in the bright light.

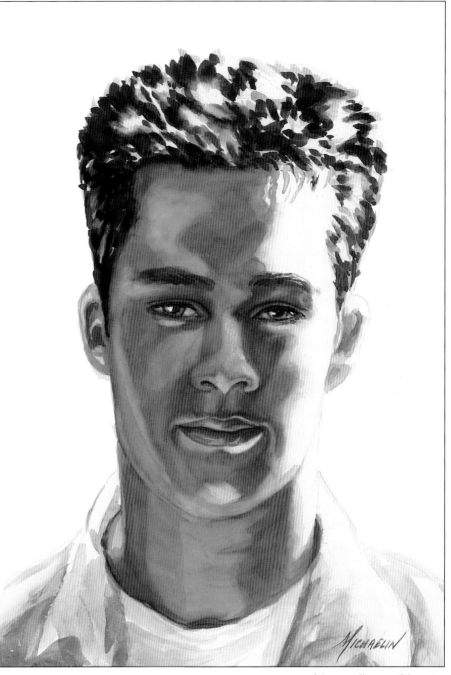

Jim • 10" x 14" (25cm x 36cm) • Collection of the artist

Tips •Painting the eyes last is really fun. The painting comes to life before you when you add the final touches of dark color.

• For more specific instructions on painting the eyes, refer to chapter one, page 20.

Profile With Facial Hair

Derrick is from Sri Lanka, and though he has a definite olive tone to his skin, we will start with Raw Sienna. If green is applied first, the color gets muddy when the additional skin tone layers are added.

Painting the background first is a good way to get warmed up for a painting. The background is often the most difficult part of a painting; if you start with the background, once satisfied, you can relax and have fun with the rest of the painting.

Look at the photo used for this painting. There are dark areas (such as Derrick's hair and beard) where losing part of the subject into a dark background would work well. We'll let the color from the dark background run right into these areas; these are referred to as *lost edges*.

Before you begin painting, always bring the colors you will be using into the mixing area of your palette. The background needs to stay wet the entire time you paint, so you will not have time to mix colors between layers.

[MATERIALS LIST]

◎ Small piece of watercolor board, 10" x 14" (25cm x 36cm)

Paints

◎ Raw Sienna
◎ Carmine
◎ Ultramarine Deep

◎ Burnt Sienna
◎ Sap Green

Brushes

◎ No. 4 round
◎ No. 6 round
◎ No. 8 round
◎ No. 10 round
◎ No. 12 round

◎ ¼-inch (6mm) flat
◎ ¼-inch (6mm) filbert
◎ ⅝-inch (16mm) flat
◎ 1½-inch (38mm) flat

Other Supplies

◎ Water container
◎ No. 2 pencil

◎ White paper towels or tissues
◎ White eraser

Reference Photo

Begin With a Line Drawing

You can enlarge and trace this drawing or draw it using the method discussed earlier (page 17). Remember to measure the width of the eye, and base the rest of the drawing on that measurement. Because the side view of the eye is a small shape, include the eyelash shape in your measurement. That makes the unit of measure a little larger and easier to work with. The tip of the eyelash shape to the bridge of the nose measures a bit less than one eye width.

Use your pencil to draw some little shapes of light into the hair and beard. Also, make some lines to indicate where the background runs into the hair and beard. This will be a reminder to you where to let the color flow into the hair.

1 | **Paint the Light Background**
Use your no. 10 round and bring out separate puddles of Raw Sienna, Burnt Sienna, Carmine, Sap Green, and Ultramarine Deep.

Use your 1½-inch (38mm) flat and wet the entire background area with clear water except for the small space behind the neck. Wet the areas where you want the color to run into the hair and beard. You'll find you can easily cut around the features with this brush.

Load the same brush with a watery mix of Raw Sienna. Use big strokes and cover the entire background, letting the Raw Sienna run into the lost edges. While still wet, pick up some Burnt Sienna (this should be slightly thicker than the Raw Sienna). Use large brushstrokes and paint the Burnt Sienna over the first layer—leave some of the first layer showing. Each layer should not completely cover the last. Notice in the illustration that some of the first color shows. Quickly move to the next layers.

2 | **Darken the Background**
Load the 1½-inch (38mm) flat with Carmine, and while the surface is still wet, add a few brushstrokes here and there. Each layer you add should have less water than the last. Next add a thick mixture of Ultramarine Deep. Keep your brushstrokes broad and flat. Finally, add a few brushstrokes of Sap Green here and there.

Create a very thin mixture of Burnt Sienna and Ultramarine Deep. Use the same brush and apply big strokes into the still-wet surface. Add as much color as you want as long as the surface is still wet. Keep the darkest color along the face. The edge of the face will be left white to create the center of interest against this dark value. Let dry completely.

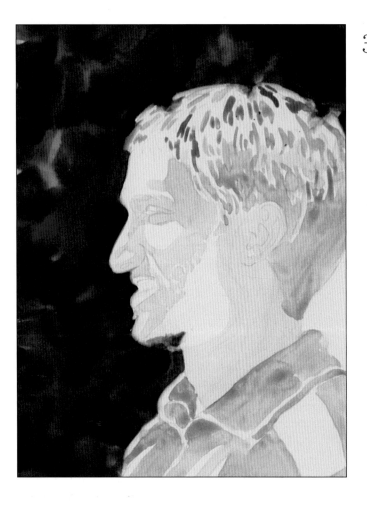

3 **Underpaint the Face**

Before beginning to layer the skin, use your ¼-inch (6mm) filbert to soften all of the edges of the face and hair. Wet the brush and dab on a paper towel to remove the extra water then run the damp brush along the dark edge to soften it. Don't go into the dark paint very far; stay along the edge. As you soften, your brush will pick up dark paint, so rinse it out every inch or so. Dab the edge with your paper towel each time you rinse your brush, to soak up excess water and paint. You may need to stroke back and forth a bit to soften the paint. When the entire edge is softened, you are ready to begin painting the skin.

On your palette, mix up a light, watery wash of Burnt Sienna and Raw Sienna. Using the no. 10 round, paint this wash over all of the skin except the white shapes on the cheek and beard.

Use the same no. 10 round to bring out thin puddles of Ultramarine Deep, Sap Green and Carmine. Paint the first layer of the shirt with Ultramarine Deep, leaving some white areas.

Use the no. 8 round to paint the small shapes of red and green in the hair. These will become highlights showing through the dark hair. Paint the rest of the hair with Ultramarine Deep, leaving some white highlights. Allow to dry.

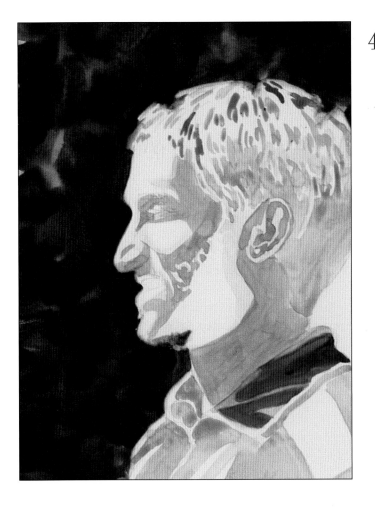

4 Add More Color

Before beginning to apply the second layer, erase as many pencil lines as you can that are near the white areas. Use your ¼-inch (6mm) filbert to soften the edges of the skin that border the white areas. Don't soften the edges along the hair and beard, as these will be dark.

Bring some Burnt Sienna into the mixing area of your palette to use for the next layer of skin. Each layer will now become darker and the shapes smaller than the first layer. With the no. 10 round, mix a slightly watery mixture of Burnt Sienna and paint the neck area. Allow some light areas from the first layer to show through. Paint the ear in the same manner. Don't paint the area on the front of the neck and the small light areas in the ear. Leave the white spaces free of paint. Don't worry about streaks; you'll smooth them out later.

Divide Into Smaller Shapes

Divide the larger areas up into smaller shapes. Use Burnt Sienna to paint the area around the eye up to the forehead. Paint the lower cheek area (still leaving the white of the paper for beard hairs) and the shadowed areas on the nose, under the nose and under the lower lip. Leave the sunlit areas light: across the forehead, the front of the cheek, on the eyelids and along the bridge of the nose.

Paint the dark shapes on the shirt. On your palette, bring out a puddle each of Ultramarine Deep and Carmine. Also mix a puddle of Burnt Sienna and Ultramarine Deep to make black. On dry paper, use the no. 10 round and paint in the darker shadowed area of the collar. The main part of the shadow is first painted with straight Ultramarine Deep. While still wet, add some Carmine, then add some of the black mixture to the back third of the collar to make it look as if the back part of the collar is in shadow. Dampen the no. 8 round and soften the edge of the shape onto the lighter collar area. Leave the stripe on the shirt collar white.

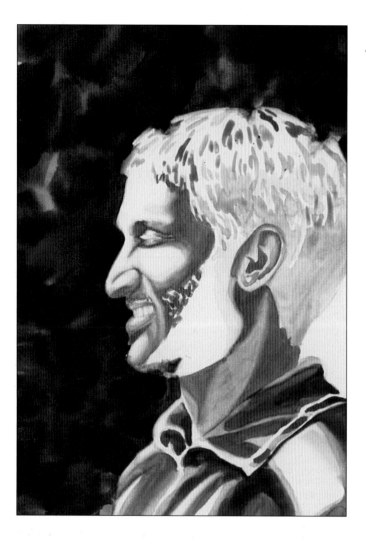

5 | Continue to Layer

Finish the shirt using the same colors as the collar. Start with the Ultramarine Deep, and while still wet, add Carmine and the black mix from step 4. Don't add Carmine to every area. Keep the white areas white; paint the sections in between them one at a time. Soften the edges with the no. 8 round as you did on the collar. When dry, soften the white edges of the shapes.

Add another layer to the face with straight Burnt Sienna. This puddle on your palette should be thicker and darker than the last. Again on dry paper, use the no. 8 round to paint the shape under the ear. After completing the shape, dampen the no. 4 round, dab out the excess water and soften the edge of the shape you just painted. Don't worry about the edge of the beard, as the dark color will soften that edge. Do not brush back and forth, use as few strokes as possible to avoid lifting the first layer. Continue with the no. 8 round to paint in the shape on the back of the neck, softening with the other brush. Paint the shape on the neck under the chin. Keep the light spot on the front of the neck. Let the area dry.

Soften the Edges

Using the no. 8 round, paint the small shapes on and in front of the ear, softening with the other brush. Also paint the area in front of and above the eye; allow to dry. Paint the area along the temple hairline up to the forehead. Always let an area dry thoroughly before painting an area that touches it. Paint the shapes on the nose, upper lip and under the lip. Soften with the smaller round brush. Let the skin dry.

Mix Carmine with a touch of Burnt Sienna and paint the lip shapes with the no. 6 round. Soften the edges with the same brush. With the same mixture, paint in the lines of the teeth. Let this dry before softening the edges with the no. 6 round to get natural-looking teeth.

Smooth the Previous Layer

6 Make sure the lip area is dry and erase any pencil lines showing on the teeth and lips.

Mix a little Raw Sienna into some Sap Green to make a thin yellow green. Avoiding the white areas, use the no. 12 brush and lots of water to paint a thin layer over the skin. This will give the skin a slight olive cast and smooth out the previous layers. Keep the wash light and use very light strokes. If you brush over it too many times, you will lift some of the layers underneath. If this happens, let the area dry and reapply the Burnt Sienna. This layer should be almost invisible except in the lighter areas. Let dry, then soften the edges of the white areas.

Add the Dark Hair

To make the deep black of the hair and beard, use the no. 10 round with very little water to mix Burnt Sienna and Ultramarine Deep. Don't rinse your brush out between the colors or you'll add too much water to the mixture. This mixture should be very thick, use just enough water to make it flow onto the paper. Use the no. 10 round and make the hair look natural by brushing dark strokes onto the hair in the direction that the hair grows. Leave lots of white streaks, as well as areas of the green, pink, and blue to look like shiny hair. Leave a lot uncovered as some of them will disappear when you soften the edges. This keeps the dark color from appearing flat.

With the no. 4 round, paint a few hairs from the hairline into the forehead and temple area. The intensity of the color will vary according to the amount of water you use. This variation will add depth to the dark value.

Paint the Beard and Ear

When the hair is complete, moisten the no. 12 round and soften the hairline along the back of the neck. Add a bit of Burnt Sienna if needed.

Use the no. 8 round and the same dark-black mixture to paint the shorter hair of the beard. Facial hair is curlier than the hair on the head, so use circular strokes. Leave the whites and highlights along the front line of the beard where the light is hitting. Use the no. 8 round with clear water to soften and blend the edges of the beard into the skin, using circular strokes.

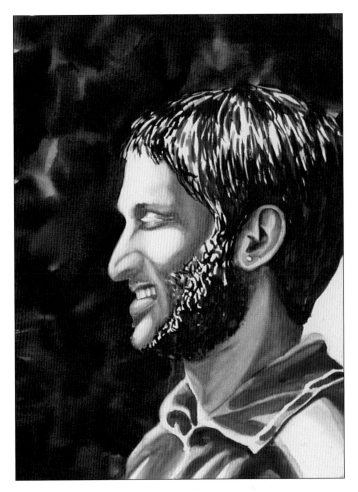

Now paint the small dark shapes in the ear. Add some Burnt Sienna to your black mixture if you have some left from the hair. If not, mix it again, but this time add more Burnt Sienna than Ultramarine Deep to make a rich brown. Use the no. 8 round and add the small shapes that form the details of the ear. Soften with the clean, damp tip of the same brush. Put in the small shadow of his earring. Add the crease in his neck with the same brush.

Using the no. 8 round, darken the lips. Mix Carmine with a small amount of the dark brown mixture on your palette to make a dark red. Add the smaller shapes to the lips and inside the mouth. Soften with the same brush, rinsed and dabbed on your towel.

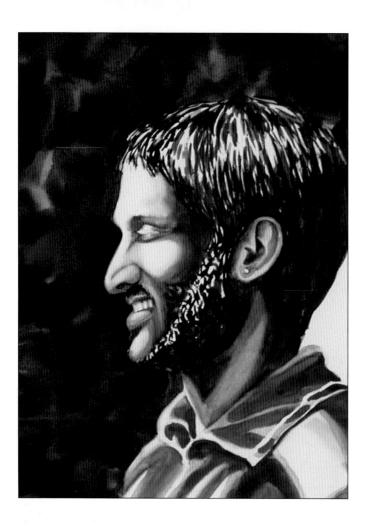

7 | Continue to Darken

Bring out some pure Ultramarine Deep for the shadow areas on the skin and shirt. The blue should be a medium consistency—not as thick as the black mixture—but with plenty of pigment. Use two brushes, the no. 8 round and the ⅝-inch (16mm) flat. Start with the darkest shapes on the neck. These shapes do not need to be perfectly smooth; remember you are painting, not duplicating a photograph. Load the flat brush and paint the shape on the back of the neck; soften with the damp no. 8 round. Paint the shape on the neck under the chin and soften in the same manner. When these shapes are dry, paint the shadow under the ear and soften.

For the shadows of the face, switch and paint with the no. 12 round and the same blue. Add a dark shape at the temple; this shape should extend from the hairline almost to the corner of the eye. While this shape is still wet, use the no. 4 round and the black mixture to make some small strokes along the hairline; this softens the edge of the hair. Rinse the brush then use the damp tip to soften the other edge that is near the eye.

Add Details

Paint the cheek in the same manner. Start with the no. 12 round and paint the blue to make the cheek darker. While still wet, use the small brush again to paint some thin, stray hairs out into the cheek. This will make the edge of the beard more natural.

Use the no. 4 round and the black mixture to paint the dark nostril and the hair on the upper lip. Add a small line around the bottom edge of the nose and cheek line from the nose into the beard. Rinse the brush and soften here and there. Add the small amount of hair under the lower lip in the same manner.

Tip By using two brushes, you do not need to be constantly rinsing pigment out of the large brush.

8 | Add the Background and Soften the Edges

Paint the small background shape behind the neck in the same manner as the rest of the background. Use the no. 10 round to fill in the area with Raw Sienna. While still wet, add Burnt Sienna, Carmine, and Ultramarine Deep. If the area appears too light, add some of the black mixture—it should match the rest of the background. With the same brush pull some of the wet background color into the shirt area to strengthen the shadow and soften the edge of the shirt. Go right over the white line and the white shoulder patch to cast a shadow there.

Dampen the no. 4 round and soften the edge of the beard by lifting out some light hairs in the cheek area. If some of the shapes get too large, fill in areas with Burnt Sienna to match the face color.

Use the ¼-inch (6mm) filbert to soften the white and colored highlights in the hair and beard. Don't soften all of the edges; it is good to have a variety of edges, soft and hard. Add color as needed.

To finish the shirt, soften the edges of the whites with the filbert, leaving a few crisp areas here and there.

Add the Eyes

With the no. 6 round and the dark black mixture, add some small strokes to the eyebrow. Soften here and there with the clean tip of the same brush. Use the dark brown mixture and the no. 6 round to add the darker shape in front of the eye. Add the creases around the eye. Switch to the black mixture for the eyelash shape. Paint only the shape, not the individual lashes. Leave a white highlight in the lash shape.

Add some fun colors to the completed face. Since you used Carmine and Ultramarine Deep in the background, mix these together to make a

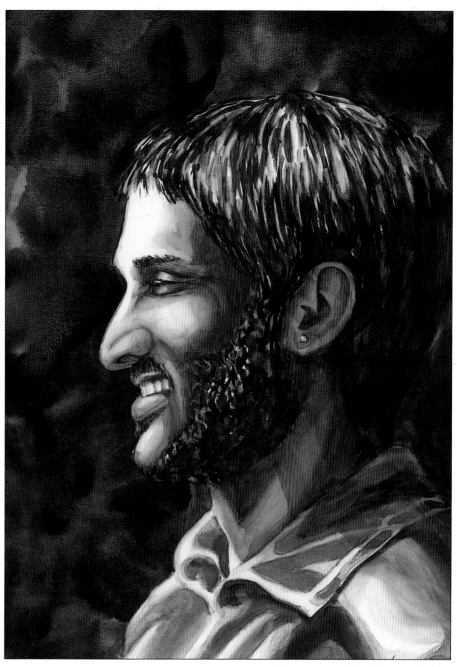

DERRICK • 10" x 14" (25cm x 36cm) • Collection of the artist

lavender. With the no. 10 round, add some of this lavender to the side of the cheek, between the eye and beard. Use broad strokes and avoid going over any area more than once or you will lift paint. Glaze over the entire ear to shadow it, leaving some little white areas on the earring for sparkle. Glaze part of the neck into the shirt shadow.

Using only Carmine, add some blush to the lower edge of the cheek and soften the edge. Your painting of Derrick is now complete.

Three Quarter View

Jodi is Korean with beautiful skin that resembles porcelain. Her complexion has a yellow undertone with some pink shining through. Her face is basically warm with some cool highlights (these will be added at the end).

[MATERIALS LIST]

⑥ Small piece of watercolor board, 10" x 14" (25cm x 36cm)

Paints

⑥ Raw Sienna ⑥ Cerulean Blue

⑥ Burnt Sienna ⑥ Carmine

⑥ Ultramarine Deep

Brushes

⑥ No. 6 round ⑥ No. 12 round

⑥ No. 8 round ⑥ ¼-inch (6mm) filbert

⑥ No. 10 round ⑥ ⅝-inch (16mm) flat

Other Supplies

⑥ Water container ⑥ White paper towels or tissues

⑥ No. 2 pencil ⑥ White eraser

Reference Photo

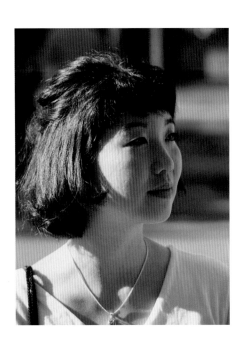

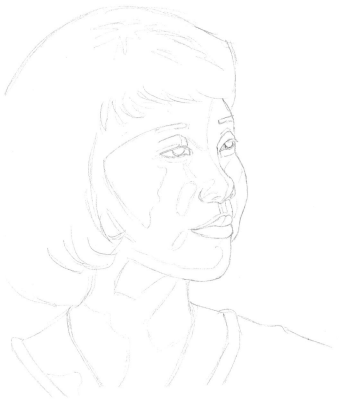

Begin With a Line Drawing

Here is the line drawing of Jodi. You can enlarge and trace the drawing or draw it using the method discussed earlier (page 23). Remember to measure the width of the eye, and base the rest of the drawing on that measurement.

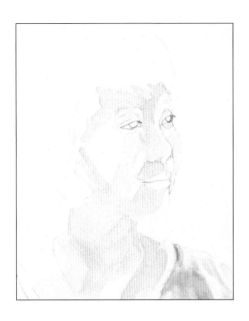

Add the First Layer

1 Bring some Raw Sienna onto your palette and mix up a watery, thin wash to apply to dry watercolor board. Use the no. 10 round to cover all of the skin on the face and neck except the areas left white and the eyes and lips. Keep this first coat very pale.

Use the same brush to apply a watery mix of Cerulean Blue to the shirt, going around the white areas. Let dry completely.

Erase all pencil lines that border the white edges. Using the ¼-inch (6mm) filbert, soften the edges of the white areas of the skin and the blouse. After this dries, use the no. 12 round with water and run it along the highlighted edge of the nose where the skin color and white meet. This transition from skin tone into white needs to be smooth, so be careful smoothing it out. Soften the edge of the cheek also, if needed.

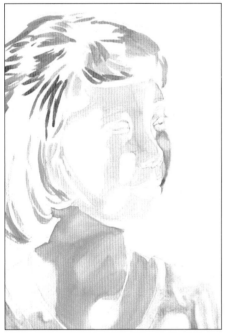

Add the Second Layer

2 With the no. 12 round, apply warm and cool streaks (in the direction of the hair) to the hair with Cerulean Blue and Burnt Sienna. These shapes will be surrounding the white highlights.

Make two puddles on your palette for the second, slightly darker layer on the skin. One is a mixture of half Burnt Sienna and half Carmine for the neck, and the other is a half-and-half mixture of Raw Sienna and Carmine for the face. Also bring out a separate puddle of Raw Sienna and one of Cerulean Blue.

Paint the Skin

Paint the skin wet-into-wet to keep it very smooth and delicate. The light is coming from the left side and striking the shoulder. Start with the neck. Using the no. 12 round with clear water, wet the neck above the necklace, up to the jaw line. Use the same brush to apply the darker mixture of Burnt Sienna and Carmine. In the light areas, add straight Raw Sienna. These colors should contain less water than the first Raw Sienna wash. Her skin should look soft and smooth.

Wet the area below the necklace and paint this area in the same manner. Leave the large area under the hair white with a soft edge. Let this dry completely.

The face is lighter than the neck so continue this layer onto the side of the face using the lighter Raw Sienna and Carmine mixture. With clear water and a small no. 8 round, wet the small cheek area on the shadowed side of the face, from the eye down to the edge of the lips. With the same brush, paint the light mixture over the whole area. Then add a bit of the darker mixture of Burnt Sienna and Carmine to the darkest areas. While this is still wet, add a little dab of Cerulean Blue to the cool shape under the eye and to the corner of the mouth. The rest of the face will be painted in the next step.

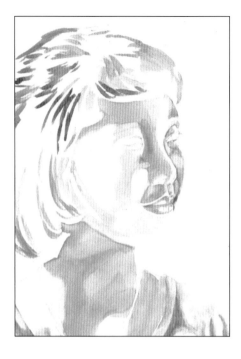

Continue Layering

3 On the shadowed side of the face, wet a small area above the left eye and above and below the eyebrow. With the no. 8 round, fill in the area with the light mixture of Raw Sienna and Carmine. Add the darker mixture of Burnt Sienna and Carmine to the crease of the lid.

Paint the skin under the nose and above the upper lip in two segments. Wet one side, then lay in the darker mix. If needed, use a damp no. 6 round to lift out lights. Repeat on the other side of the upper lip. On the shadowed side, add a bit of Cerulean Blue to the shadow (the brush should be just barely damp with the blue).

Use your no. 8 round to wet the forehead down to the nose. While still damp, load the no. 8 round with the dark mix and darken the area on the side of the nose near the eye. Let dry.

Use Carmine and the no. 8 round to paint the lips on dry paper. Leave the highlighted areas white.

The second layer on the blouse is painted on dry with the no. 8 round. Using Cerulean Blue, paint in the darker areas of the creases of the blouse and soften the edges.

Continue Modeling the Face

4 Use your no. 8 round to wet the area above the right eye, on the lid near the inner corner. Then apply the dark mixture of Carmine and Burnt Sienna. While still damp, add Cerulean Blue along the edge and soften if needed. Add a slightly thicker dark mixture into the crease.

Use the no. 10 round to wet the entire side of the face beginning at the eye, along the nose, and down to the chin, including the area under the mouth, then lay in the light mixture of Raw Sienna and Carmine. Paint right over the light shapes beside the nose and mouth and over the chin. The only part left white is the large area on the cheek. Go over the white areas along the chin to the jaw (this should be a very light layer). Soften the white edge if needed. Let dry.

Soften the highlighted edges of the lips with the ¼-inch (6mm) filbert. Using the no. 8 round, mix Carmine with a touch of Cerulean Blue to make a darker red and paint the darker areas of the lips; soften if needed. Let dry completely.

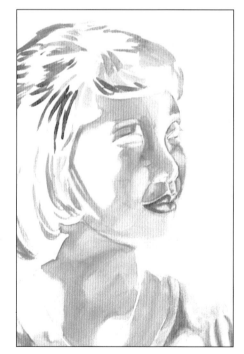

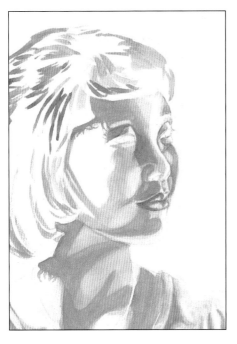

5 Continue to Darken

Using a small amount of water and the no. 8 round, make a dark mixture of Burnt Sienna and Carmine and darken the shapes on the face. Paint the shape on the shadowed cheek first. Paint around the light areas, then soften the edges.

Still using the same brush and color, go to the other side of the face and paint the small shape on the side of the nose and upper lip; soften the edges. Let dry. Paint the shape that runs along the side of the nose and up to the eyelid, including the eyelid shape. Bring a few stray hairs out into the white space below the eyebrow.

While that is drying, paint the shape on the chin and soften.

Paint the shapes on the neck in the same manner, going around the lights and softening. The nose should be dry enough to paint the shape on the forehead and across to the hair. Include some hair shapes at the edge of the white space; soften and let dry. Leave the entire cheek shape alone; the rest of the face must be totally dry before painting.

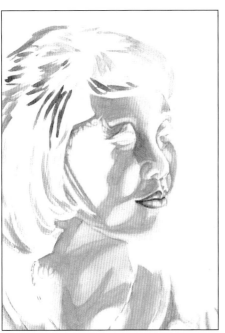

6 Darken and Soften

Using the dark mixture of Burnt Sienna and Carmine, add the cheek shape from the eye down to the shape on the chin and across to the hair shadow. Let dry completely.

Using the small damp filbert, soften the edges along the white area of the cheek and neck.

Finish the mouth by mixing Carmine and Burnt Sienna (with a touch of Cerulean Blue to darken). With the no. 8 round, paint the line between the lips and the dark shapes on the lips. Rinse the brush and soften.

Using the same brush, paint the little shapes on the necklace with Raw Sienna and Burnt Sienna. Don't paint the entire necklace; leave some areas white.

7 | Begin Painting the Hair

Paint the last dark shapes on the face and neck. Do not soften; the softening will be done with a smoothing coat. Mix Burnt Sienna and Carmine with a small amount of water to make a nice dark. Use the no. 8 brush and paint in the shapes on the face; these are smaller and darker than the last shapes. Paint all the shapes you see; do not worry that it looks blotchy. Let dry completely.

Mix Burnt Sienna and Ultramarine Deep into a very thick, black mixture and use the no. 8 round to paint the hair (in the direction it grows); leave the whites and the colored shapes showing. Leave more of the lights than you actually want, as softening later will cover some of them.

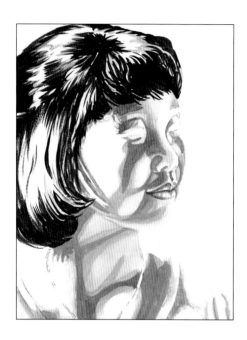

8 | Add the Smoothing Glaze

For the smoothing glaze, mix a thin and watery puddle of Raw Sienna with a touch of Carmine. Using the no. 10 round, begin the neck shapes. There are three main areas of the neck, one on each side of the necklace and one in the middle. Start with one of the smaller areas. Using light strokes, brush the watery wash over the area. Dry the brush out on a paper towel and lift any areas that appear too dark. Soften the white edges. You can actually stroke over the areas several times before it will start to lift up the previous layers. If the layers begin to lift, pick up some of the darker mixture and reapply. Let dry, and if needed, smooth again with the light mix. When smoothing the large cheek area, bring a little of the light color into the white area and soften with another brush. When smoothing the small cheek area, bring some of the light mixture out to the outer edge of the face. In the space above the eye on that side, cover all of the white area except for the line running up the nose and onto the forehead (leave that area white).

Soften the Highlights

Soften the highlights on the hair using the ¼-inch (6mm) filbert brush. Dampen the brush, dab out and run it along the edges of the dark in the hair; rinse your brush frequently. Leave some crisp areas here and there for variety. Soften the brown and blue highlights as well as the white ones.

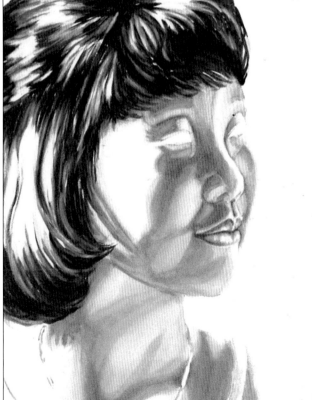

9 | Finish the Neck and Eyes

Using the no. 10 round, darken the neck with another glaze of Burnt Sienna and Carmine. Cover the white areas except for the sunlit area on the shoulder. Soften the jawline, if needed, with a damp no. 8 round. Let dry.

Use the no. 8 round and some Carmine to add a bit of pink to the cheek area, soften the edge. Lift along the white edge, if desired, to add an interesting shape along the cheek line.

Use the ¼-inch (6mm) filbert to soften the necklace.

Add Soft Shadows

Add some soft Cerulean Blue shadows to the face. Use the no. 6 round and apply a shadow to the side of the nose—use a very light touch. If needed, soften with the same brush. Add a blue shadow to the upper lip in the same manner. Add a shadow from the corner of the mouth into the chin. Bring this shadow all the way along the jawline to the shadow of the hair. Using the same no. 6 round, add the small shadow on the eyelids and inner corners of the eyes. Let the face shadows dry.

Using the ⅝-inch (16mm) flat and Cerulean Blue, glaze the shadow on the neck, shoulder and onto the blouse. Make the edge of the blue run along the contours of the fabric. With the no. 12 round, add the other blue shapes to the neck. Let dry.

Add the Darks

With the no. 6 round, add the dark shadows under the necklace with Cerulean Blue. Use a darker mixture of Cerulean Blue to add the shadow under the edge of the blouse.

Use the no. 6 round and paint the eyebrows with a black mixture of Burnt Sienna and Ultramarine Deep. Paint them one at a time, softening here and there.

Glaze the Eye

Water down some of the black to make a gray, and using the same brush, glaze over the white of the eye, iris and pupil, leaving the highlights white. Let dry. With the no. 6 round and Burnt Sienna, paint the iris. Using the dark black mixture of Burnt Sienna and Ultramarine Deep, use the no. 6 round to outline the eyes and paint the dark pupil. Leave the white highlight. Add some eyelash shapes without painting the individual lashes. It looks a bit harsh at this point, but it will be softened in the next step. Let dry.

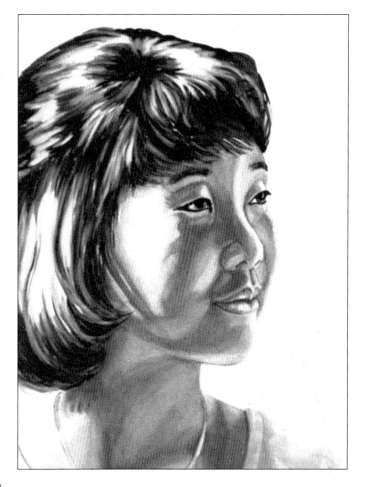

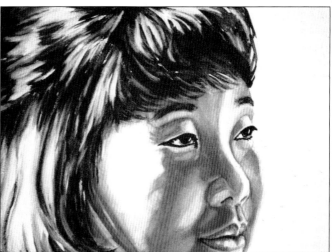

The eyes look a little harsh at this point, but they will be softened in the next step.

10 Soften the Harsh Edges

Using the tip of the no. 6 round, carefully soften the lines around the eyes. Soften the inside edge into the white. Let dry.

The dark black hair against the stark white of the background can be distracting. With the ¼-inch (6mm) filbert, soften here and there around the outer edge of the hair into the background.

Using the black mixture, darken the hair right along the white of the cheek. The strong contrast draws attention to the center of interest, the eye area.

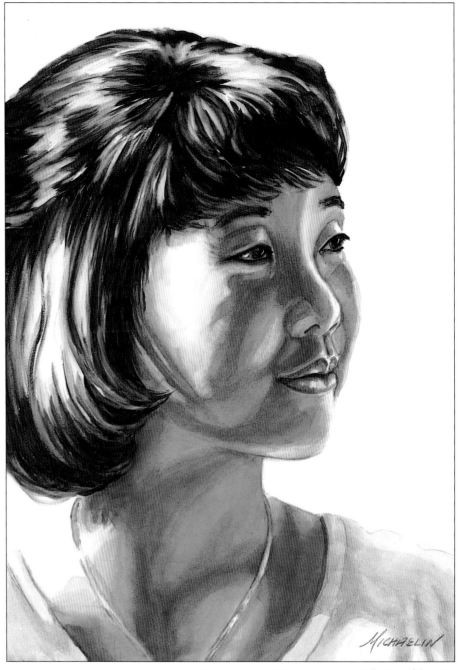

JODI • 9" x 12" (23cm x 30cm) • Collection of the artist

The Aged Face

Painting the aged face is exciting and challenging. Mature faces are my favorite to paint because they show character and wisdom that younger faces sometimes lack. Painting them is similar to painting younger faces, with a few differences. Older skin has less elasticity, so the jaw line is less distinct. Also, there are the dreaded wrinkles, which are actually fun to paint if you don't overdo it. Older Caucasian skin is usually more sallow than its youthful counterpart. Older skin of some other nationalities is less smooth in color than younger skin.

These differences add a lot of personality and soul to the face, making it really fun to portray. Think of all of the great paintings you have seen of older people, from salty fishermen to older Native Americans. There are many artists who obviously love to paint the well-aged face.

Getting a likeness should always be secondary to creating a good painting. The goal as an artist is for viewers to be attracted to the aesthetics of the painting as a whole, not just because they know the subject personally.

[MATERIALS LIST]

⊚ Small piece of watercolor board, 10" x 14" (25cm x 36cm)

Paints

⊚ Raw Sienna

⊚ Carmine

⊚ Ultramarine Deep

⊚ Burnt Sienna

Brushes

⊚ No. 6 round

⊚ ¼-inch (6mm) filbert

⊚ No. 8 round

⊚ 1½-inch (38mm) flat

⊚ No. 10 round

Other Supplies

⊚ No.2 pencil

⊚ Water container

⊚ White paper towels or tissues

⊚ White eraser

⊚ Piece of drawing paper for value study

⊚ 2 Prismacolor markers (gray and black)

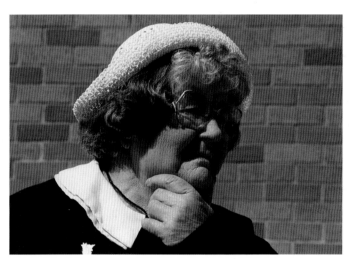

Reference Photo
Katherine and I met at an art show, and I was immediately drawn to her darling smile and cute hat. When I am drawn to someone immediately, I love to photograph and paint them. I hope because I was drawn to the face that viewers of the painting will be as well.

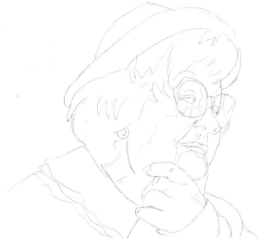

Create a Line Drawing
As you draw Katherine, use her glasses to help position her features. Make sure the angle of her glasses and eyes is the same.

1 Begin with a Value Study

A value study is an invaluable tool for creating a good painting. Draw another rough pencil sketch of Katherine on a piece of scratch paper. The white hat and collar is a great area to lose an edge into the background. Design a white shape that connects the hat and collar in the back and the hair and hat in the front of the face. Draw the white shapes of the face; notice that they are all connected to the white shape in the background, which in turn is connected to three sides of the paper.

Now use the gray marker to color in all but the white shapes. Use the black marker to color in the dark shapes. Since the white shape is so well connected, it will lead the viewer's eye through the painting. You have now established a plan to follow for this painting.

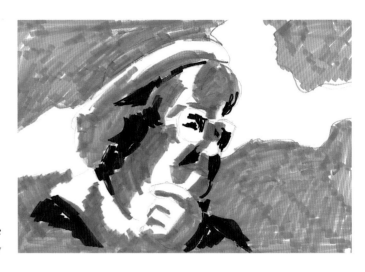

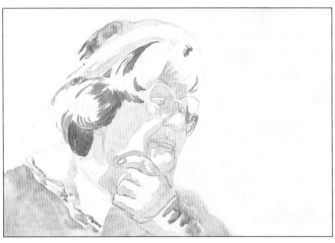

2 Add the First Layer of Color

Now let's go back to your original sketch and begin painting. Use the no. 10 round to mix a watery wash of Raw Sienna and Carmine and paint a light coat on all of the skin except the white areas. Go around the glasses, leaving a white line for the frames. Paint the area inside of the frames on and around the eyes.

With the no. 10 round, bring out some Ultramarine Deep and apply a wash on the blouse and in the shadows of the multi-layered collar and hat. Leave the white shapes.

While still wet, you can darken the Ultramarine Deep in the shadowed areas of the blouse. Wait until the blouse dries to add the second coat on the sleeve .

Paint the shadowed areas of the hair. Mix some Ultramarine Deep and Burnt Sienna with lots of water to make a light, brownish gray. With the no. 8 round, paint in the darkest areas of the hair. Make sure to keep the brush strokes going in the same direction that the hair goes.

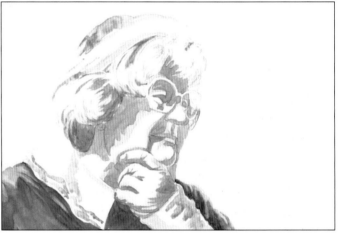

3 Add More Color

Use the ¼-inch (6mm) filbert to soften the edges of skin that border the white areas.

Mix more of the skin tone mixture, Carmine and Raw Sienna, using less water than for the first layer. Use the no. 8 round to paint the darker shapes in the skin; leave the white and the lighter areas. Since this is not the darkest layer, do not worry about hard edges. Like we did in the other demonstrations, we will smooth them later.

Use the no. 8 round and straight Ultramarine Deep to paint some blue highlights into the white area of the hair. This should be a fairly light, watery mix.

Add another layer to the blouse. Using the no. 10 round, bring out some Ultramarine Deep and mix in a bit of Burnt Sienna to gray it down. Burnt Sienna is actually an orange, so we are adding orange (the complement of blue) to gray down and darken the bright blue. Leave some of the original light blue showing. With the no. 8 round, paint the darker areas of the blouse and soften the edges. Paint the areas separately, starting with the small area to the right of the arm. Skip over the sleeve to the other side of the blouse. Let dry.

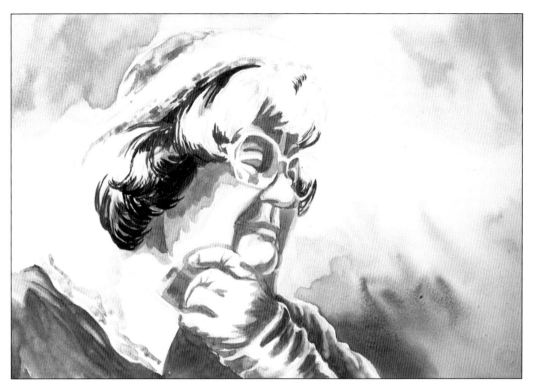

4 | Continue Adding Layers

Use the no. 8 round to mix Raw Sienna and Carmine with even less water than the last layer. Paint the darker areas of the skin, continuing to go around the frame of the glasses.

The darkest layer of brown on the hair is painted with the no. 8 round and a thick mixture of Ultramarine Deep and Burnt Sienna (use more brown than blue to make a dark brown). Make dark strokes in the direction of the hair. Add some strokes in different directions for the curly sections of hair. Let dry.

Add Texture and Darken

Use the no. 8 round with pure Raw Sienna to add some texture and warm color to the hat. While still wet, add a few additional strokes of Burnt Sienna. Let dry.

Darken the sleeve that you skipped in the last step. Use the blue mixture of Ultramarine Deep and Burnt Sienna, still using the no. 8 round. Soften with a clean, damp brush.

Begin the Background

Clean off the mixing area of your palette and bring out four puddles: Raw Sienna, Burnt Sienna, Carmine and Ultramarine Deep. With the 1½ (38mm) flat, wet the entire right side of the background. Even though you will only be painting the bottom section right now, you want the edge of the white shape soft so you need to wet the entire space. Cover the whole area of the bottom shape with a thin coat of Raw Sienna. While still shiny and wet, use the same brush to add some Burnt Sienna, leaving lots of the Raw Sienna showing. Next add some Carmine and then Ultramarine Deep, each time leaving some of the other colors showing. The surface should be wet for all of the colors, each one getting a bit thicker. Let dry completely before going on to the other areas.

With the 1½ (38mm) flat, wet the left side of the background. Again, even though the paint will stay in the top section, wet the entire side down to her collar. Start with Raw Sienna, add Burnt Sienna, Carmine, then Ultramarine Deep.

When both sides are completely dry, wet the upper right corner and add only the Raw Sienna and Burnt Sienna. Wet farther than the paint will go to keep the white edge soft. Make sure to leave the white shape running off the edge of the paper. Let dry.

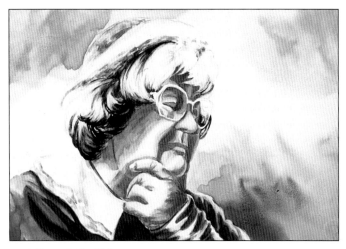

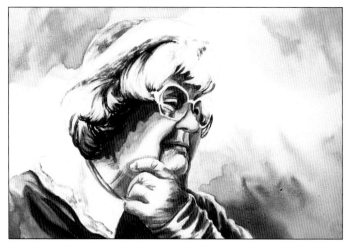

5 | **Smooth the Skin**

Erase any pencil lines that show, especially in the hair or background.

Use pure Raw Sienna and the no. 8 round to smooth the skin. Start with the smaller shapes and work up to the larger ones. Let some of the Raw Sienna show along the white edges. Soften the white edges as you go with the same clean, damp brush. Let dry.

Paint the darkest areas of the blouse with the no. 8 round and a very thick blue-black mixture of Ultramarine Deep and Burnt Sienna; soften as you go. The ¼-inch (6mm) filbert is used to soften the shadows on the collar. Add a touch of Raw Sienna here and there to add warmth to the cool blue collar.

Using the same filbert, soften the hair. Leave a few crisp areas. Make sure to leave the white edges that are lost into the background.

With the no. 6 round, paint the necklace using Raw Sienna; add Burnt Sienna at each end to show the shaded areas.

6 | **Add the Shadows and Eye Shapes**

For the cool shadows on the face, use the no. 8 round and straight Ultramarine Deep. The mix should be slightly watery. Paint the shadow on the side of the cheek under the hair. The edge is wavy because of the shadow cast by the hair. Soften the edge with a clean, damp brush. Paint the shapes above and below the eyes and under the hair on the forehead. Continue down the face and to the hand. Paint a thin shadow under the necklace.

Use Burnt Sienna and the no. 6 round to paint the small lines on the fingers and chin. Soften here and there so they don't appear too harsh.

With the darkest black mixture, paint the eye shapes. Because they are behind the glasses, they do not need a highlight. Allow to dry.

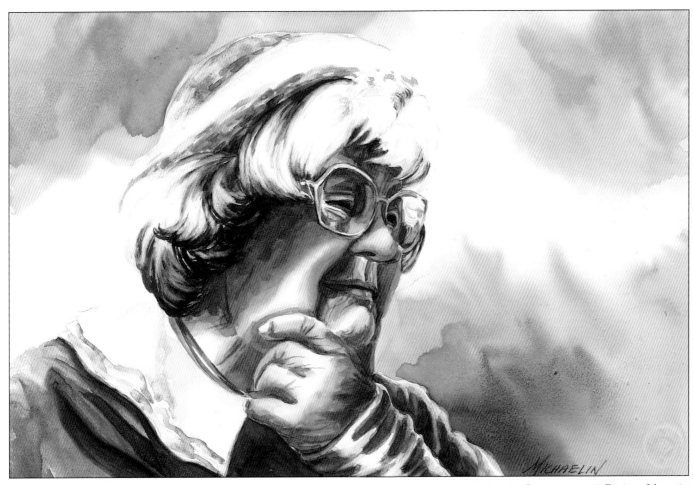

7 | Add the Finishing Touches

With the no. 6 round and the dark black mixture of Ultramarine Deep and Burnt Sienna, outline a few areas on the frames of her glasses. Do not outline the entire shape; leave some to the imagination. Fill in some of the areas with Raw Sienna to make them appear gold. Leave some untouched. With the ¼-inch (6mm) filbert, lift out a reflection on the lens, near the nose.

With the no. 8 round, wet the cheek area and add some Carmine to make her cheek rosy. Because Carmine is a very staining color, it is safer to wet the area first rather than applying to dry paper and then trying to soften the edge. Also, apply a little Carmine along her knuckles and a touch on her nose.

5 painting CHILDREN

Children actually have a less distinctive form than adults—they are slightly rounder and softer
looking and have less obvious light and dark shapes. Because the shapes of these areas of light and dark make the picture look like the person you are painting, it is harder to get a likeness in a child. Their faces are rounder and less angular and therefore cast less dramatic shadows. ✆ Children's skin is always much clearer, and at times pinker, than adult skin. Caucasian children require more transparent, pure colors than their adult counterparts. Permanent Red and Aureolin make a perfect mixture for the skin of Caucasian children. The yellower adult skin is achieved with Carmine and Raw Sienna (a more grayed-down yellow). ✆ Dark-skinned children tend to have lighter skin than dark-skinned adults. For the first layer of color on a dark-skinned adult, I most often use straight Burnt Sienna, while on a child, I mix a bit of Carmine into the Burnt Sienna to make a clearer, pinker tone.

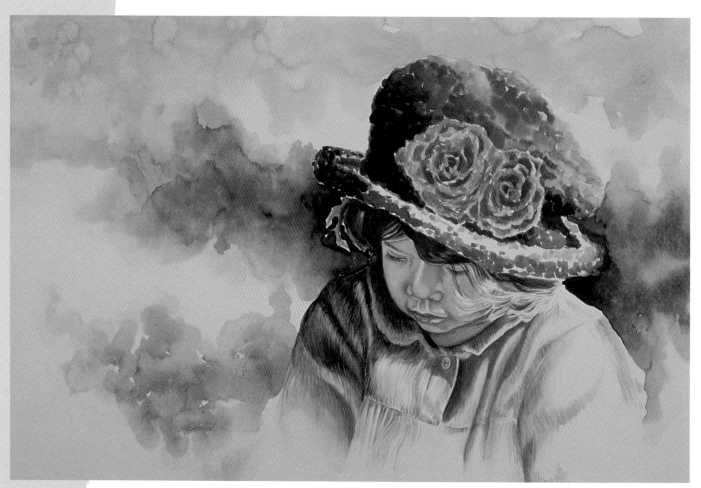

MADELINE • 22" x 30" (56cm x 76cm) • Collection of Mr. and Mrs. Richard Melamed

A Young Girl in Native Attire

This darling Mayan girl lives in Guatemala. Her family are weavers; the colorful, native huipil (dress) that she is wearing was made by her mother.

Reference Photo

[MATERIALS LIST]

⬙ Small piece of watercolor board, 15" x 20" (38cm x 51cm)

Paints

⬙ Raw Sienna

⬙ Carmine

⬙ Aureolin

⬙ Bright Violet

⬙ Burnt Sienna

⬙ Ultramarine Deep

⬙ Turquoise Blue

⬙ Cerulean Blue

Brushes

⬙ No. 4 round

⬙ No. 6 round

⬙ No. 8 round

⬙ No. 10 round

⬙ ¼-inch (6mm) flat

⬙ ½-inch (12mm) flat

Other Supplies

⬙ Water container

⬙ No. 2 pencil

⬙ White paper towels or tissues

⬙ White eraser

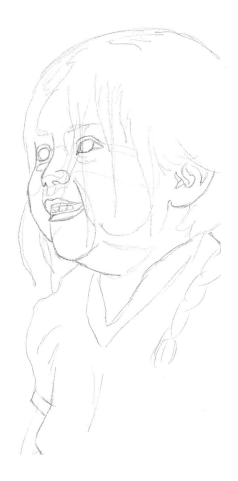

1 **Draw Sahrita**
Draw Sahrita on your board, or enlarge and trace this drawing. Make sure to draw the stray hairs that cross her face and the white shapes in her skin.

2 | Apply the First Layer

Make a watery mixture of mainly Burnt Sienna with a touch of Raw Sienna and Carmine. This will be a rosy-brown skin tone mixture. Apply the first layer of color to the skin using the no. 8 round. Paint around the white areas and around the stray hairs. Use a damp no. 4 round and soften where the color meets the white edges. Carmine is very staining, so it is best to soften as you go, before it dries. The stray hairs actually divide up the areas, making smaller, more manageable shapes to paint. Do not soften the outside edge of the face or the edges that will be against the hair. Also paint the small section of the arm. Allow to dry.

3 | Apply More Skin Tone

Use the same skin tone mixture to paint the second layer of the skin. Then mix Burnt Sienna with a touch of Carmine and Raw Sienna into a darker, thicker mix. Beginning with the shapes on the forehead, paint in the darker shapes using the no. 8 round. Work your way down the face, carefully softening the edges as you go. You will be smoothing out the skin later, so don't worry if some of the edges do not soften.

Paint the lips with a very light, watery wash of straight Carmine. Use the no. 6 round, leaving a white edge along the lips.

Paint in the dark area on the arm.

4 | Add Some Darks

With a thick mixture of Burnt Sienna, Ultramarine Deep and a touch of Carmine, use the no. 8 round to add the darker shapes near the eyes. Darken the outer edge of the forehead and soften with a damp, clean brush. Paint the rest of the areas. The shapes near the nose, corners of the mouth and the chin do not need to be softened; you will smooth them out in the next step. Paint the two small dark shapes; one is on the chin, and one is right under the chin. Also, paint the small, dark area on the arm and the small shapes on and in the ear.

With the no. 6 round and a stronger puddle of Carmine, paint the small, darker shapes on the lips.

Tip For very natural-looking teeth, remember to paint first, then soften.

5 | Smooth Out the Skin

Smooth out the skin with the same mixture used for the first layer (step two). With the no. 8 round, gently stroke on the color one section at a time, smoothing out the harsh shadows. Soften the white edges as you go. Let dry.

Paint the lips using the no. 6 round and a thick, dark mixture of Burnt Sienna and Ultramarine Deep with a touch of Carmine. Paint the inside of the mouth and around the teeth then run a thin line above the teeth on the lip. Let this dry completely before using the ¼-inch (6mm) flat to soften the teeth. Rinse the brush often to avoid smearing the color onto the light teeth. Add this same dark mixture to the nostrils, the creases on the side of the mouth and the creases on the eyelids.

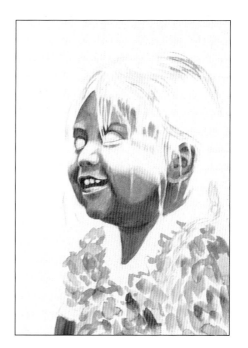

Paint the Huipil and Add Highlights in the Hair

The huipil is covered with hand-embroidered flowers and designs. Instead of painting all the details, paint it quickly and loosely to simply indicate the design. Use the ½-inch (12mm) flat and Aureolin, Turquoise Blue and Bright Violet. Beginning with the yellow, paint short strokes, twisting the brush to make interesting shapes. While still wet, use the same brush and add the purple areas with Bright Violet. Allow the two colors to softly run together. Lastly, add the Turquoise Blue. Because Turquoise Blue is an opaque color it is best to use it last. Paint around the braid. Let dry.

Use the no. 8 round to add the colored highlights in the hair. Use Cerulean Blue and then Burnt Sienna. Make the brushstrokes go in the direction of the hair, even on the braid. Because the hair will be very dark, paint lots of highlights. You can cover up any unwanted color with the black later.

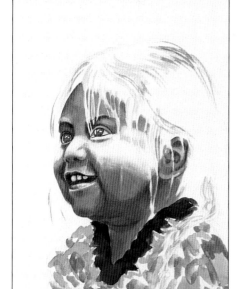

6 | Add More Color

Use the no. 8 round and the dark mixture you used for the lips to paint the eyebrows: Ultramarine Deep, Burnt Sienna and a touch of Carmine. Do not paint individual hairs, just the general shape of the eyebrow. Let dry.

With the no. 8 round, use straight Burnt Sienna to paint the irises of the eyes. Paint around the highlights, but paint right over the pupil area. Let dry.

Mix Ultramarine Deep and Burnt Sienna with very little water for a thick, rich black and use the no. 10 round to paint the collar and edge of the sleeve. Paint around some of the yellow to indicate that these are large yellow stitches. You may need more than one layer to get it dark enough; let dry between layers.

Glaze the Cheek

Put some blush on the cheek by glazing the cheek right up into the white area with Carmine. Use the no. 10 round, wet the white area to keep the edge soft, then glaze the entire cheek, letting some of the Carmine bleed into the white. You can lift along the edge to soften if needed. Because Carmine is staining, it is best to wet the edge first. Her face now has a healthy glow.

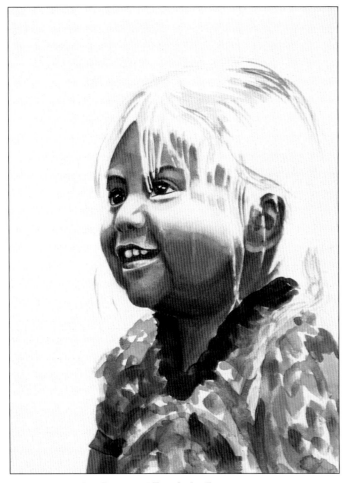

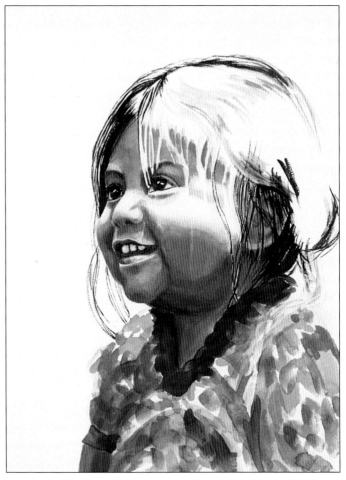

7 | **Add Another Layer and Finish the Eyes**

If needed, add another layer of Carmine to the cheek—mine still looked a bit pale. Make sure the previous layer is dry, and wet along the white edge with the no. 10 round, then gently stroke over the cheek one more time. Add a bit of Carmine on the end of her nose as well.

Using the black mixture of Ultramarine Deep and Burnt Sienna, paint the pupils in her eyes with the no. 4 round. Again, leave the highlights white. With the same brush, continue using this dark mixture to paint her eyelash area. Do not paint individual hairs, just a shape to indicate her lashes and the shadow the lashes cast on the eye itself. If necessary, soften this shape with the tip of the clean, damp no. 4 round.

Paint the shadows on her clothing with a watered-down mixture of the black. Use the ½-inch (12mm) flat to stroke in the shadows on her garment, then use water to soften. This will smear some of the original color, which helps to soften it and makes the shirt look more three-dimensional.

8 | **Paint the Hair**

The last area to paint is her wispy, tousled hair. Mix a large, very thick puddle of Ultramarine Deep and Burnt Sienna. Starting with the left side (the side of the face farthest away), use your no. 8 round to brush in the hairs. You are actually painting some of the individual hairs to accentuate the wispiness, so use long strokes and a very light touch. It is okay if the brush skips and doesn't paint a solid line. Fill in the small area right next to her face with solid black. Bring some of the long strokes from the cheek all the way down to the shoulder. It is easy to overdo at this point, so limit the number of hairs on this side. Leave lots of white on top of the head to indicate highlights.

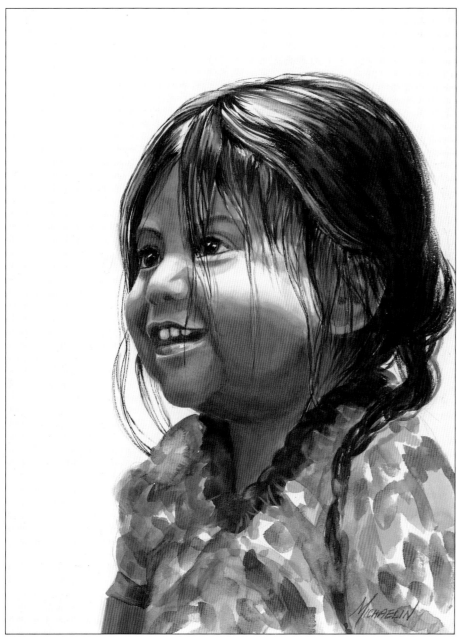

9 | Add the Finishing Touches

When the left side is complete, move to the right side behind the neck. Again, stroke in the direction that the hair is actually going. Bring some hairs over the ear and down the braid with the no. 8 round. After stroking down over the ear, use the ¼-inch (6mm) flat to lift out the hair that sweeps over the ear toward the braid. This will make the hair hanging over the ear look like it is behind the other hair.

Continue adding the hair, leaving white highlights. When you feel this is complete, let dry. To add variety, use the ¼-inch (6mm) flat to soften and lift some lighter values from the darkest part of the hair.

Continue down the braid, softening the end out with water. Complete Sahrita by adding a spot of Burnt Sienna for the tie that holds the braid.

SAHRITA • 10" x 14" (25cm x 36cm) •
Collection of the artist

Young Girl with Hat

Ashriel is the beautiful ten-year-old daughter of a friend. There are thirteen gorgeous children in her family, most of whom I have painted several times.

[MATERIALS LIST]

⬙ Small piece of watercolor board, 15" x 20" (38cm x 51cm)

Paints

⬙ Raw Sienna
⬙ Carmine
⬙ Vermilion or Brilliant Orange
⬙ Sap Green

⬙ Burnt Sienna
⬙ Aureolin
⬙ Ultramarine Deep
⬙ Shadow Green

Brushes

⬙ No. 6 round
⬙ No. 8 round
⬙ No. 10 round

⬙ ¼-inch (6mm) filbert
⬙ ½-inch (12mm) flat
⬙ ⅝-inch (16mm) flat
⬙ 1½-inch (38mm) flat

Other Supplies

⬙ Water container
⬙ No. 2 pencil

⬙ White paper towels or tissues
⬙ White eraser

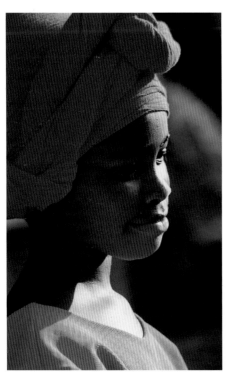

Reference Photo

1 | **Begin With the Value Study**
Draw or enlarge and trace this drawing of Ashriel on your watercolor board. The value study has been done for Ashriel on pages 26 and 27, so you can begin painting right away. Draw all of the light and dark shapes in the face.

2 | **Begin the First Layer**
Make a watery wash of Raw Sienna and Burnt Sienna with a no. 10 round and paint the first layer of skin color. Paint the entire face and neck, leaving the lightest areas white. Let dry completely, and soften all of the white edges with the ¼-inch (6mm) filbert. Leave the edges of the clothes unsoftened.

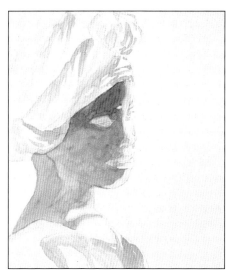

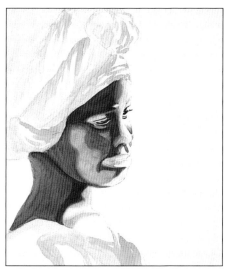

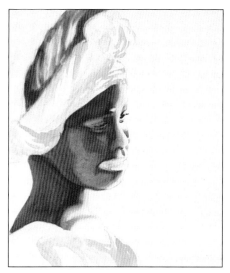

3 | Apply the Second Layer

Using the no. 10 round, mix Burnt Sienna and Carmine into a second layer. With the same brush, paint all of the skin except the white and the light edges bordering the whites. Leave the right eye and the spot above the eye light. There is also a light area on the eyebrow. Soften the edges with a damp brush as you go.

Since the lightest color of any area is painted first, you will start with the lightest color in the hat and dress. The final color will be orange, but start with yellow, the lightest primary color. Bring out Aureolin onto your palette and with the no. 10 round paint in the fabric of the clothes. Leave whites in the highlight areas. The fabric of the hat is wrapped, so make your strokes go in the direction of the cloth.

4 | Add Shapes to the Face

With the no. 8 round, mix up a fairly thick puddle of Burnt Sienna. Paint the darker shapes of the face, starting with the large shape at the front of the forehead that extends to the temple. Let that area dry before continuing down the cheek shape. You can see the hard edge where one color stopped and the other began; the smoothing layer will eliminate that. Soften the edges as you go with the small, damp filbert. Continue down the nose and include the small shapes in the eye and lash in that shape. Do not paint right next to a wet shape; wait until it is completely dry. The shape under the nose continues alongside the lips and onto the chin. The neck is one large shape. Let dry.

5 | Add Vermilion

Using the no. 10 round, bring out Vermilion or Brilliant Orange onto your palette. This glaze will cover the skin except for the white areas. Start with the neck and wet just the light edge. Then with the no. 10 round, glaze the entire neck up to the jaw line, leaving the white area alone. By wetting it first, the edge will be soft. Let dry.

Wet the edge of the forehead, nose and chin, then glaze the entire side of the face with the Vermilion and the no. 10 round. Let dry. Lastly, wet the small areas on the other side of the face and glaze these areas with the no. 8 round.

Begin painting the orange on the hat. With the no. 8 round, wet the darker areas on the hat; using the same brush, add Vermilion into these areas, allowing some of the yellow to show through.

Tip Vermilion is a very expensive color, but it is worth every penny. You can use Brilliant Orange as a substitute if you wish.

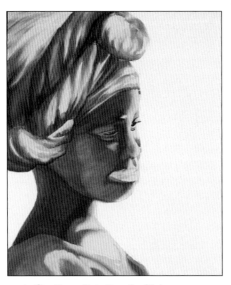 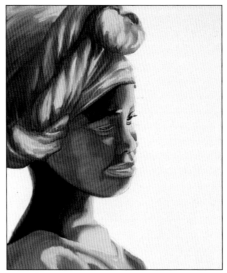 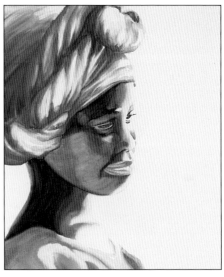

6 **Continue Painting the Hat**

Continue with the hat. Wet each shape and paint using the no. 8 round and Vermilion. Let each shape dry before painting the area next to it.

When you are finished adding the orange, bring out a mixture of Burnt Sienna and Ultramarine Deep for the shadows.

Do not prewet; use the no. 8 round and add some dark shadows in the folds of the hat.

Use the 1½-inch (38mm) flat to prewet the entire dress. With the same brush, add Vermilion to the dress, leaving the lightest yellow and white areas.

Wet the white areas of the face only, and glaze with Vermilion using the no. 10 round for the large areas and the no. 8 round for the small areas.

7 **Add the Darks**

Use the no. 8 round and paint a light layer of Carmine on the lips; leave the white areas and soften the edge.

Wet the top section of the hat. Using the ½-inch (12mm) flat, apply another layer of Vermilion. While still wet, use the same brush and Burnt Sienna to darken the shadowed area.

Mix a large puddle of Ultramarine Deep and Burnt Sienna to make a very thick, dark brown. On dry paper, use the no. 8 round to lay in the shape above the eye on the forehead (this shape includes the eyebrow); have the clean, damp no. 6 round handy to soften the edges as you go. Soften the temple edge, then the edge near the forehead; add more dark to the eyebrow. Let dry.

With the same dark brown, paint the shape on the upper lip that includes the nostril and continues around the mouth. Below the mouth and on the chin the color is a bit lighter; just add a touch more water to the mix. Soften with the no. 6 round. Paint the large shape on the neck with the darker mix and soften the edge. As you soften the jaw line, it will pull some of the dark color along the jaw. Allow to dry. If the dark appears a little streaky, it can be smoothed later.

8 **Begin to Add Details**

With the no. 8 round and the dark brown mix, paint in the dark shape from the temple running under the eye to the nose; soften with the no. 6 round. Let dry before continuing. Add a little more water to the mixture and paint the lighter shape on the cheek and nose. Soften and let dry. Darken the line at the corner of the mouth and soften with the no. 6 round.

Tip The darkest areas of the skin add drama to this painting. While they may seem too dark at first, they will be balanced out by the dark colors of the background.

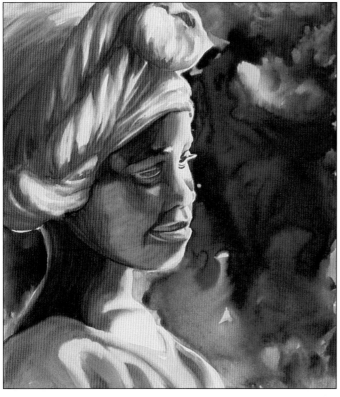

Tip Stroking over previous layers of paint too many times will lift the paint. If this happens, let dry and reapply the dark.

9 | Add the Background

The last dark shape is from the cheek to the jaw line. Add this with the no. 8 round and soften with the no. 6 round.

With the no. 8 round, mix a dark lip color of Carmine and Ultramarine Deep. Use the no. 8 round and paint the darker shapes on the lips; soften with the tip of the no. 6 round.

A decision needs to be made about the color of the background. Always consider complements of the colors in the subject. Either blue or green would work well because the main color, orange, is the complement of blue, and orange contains a lot of red, which is the complement of green.

Clean out the mixing area of your palette. When about to paint a dark, rich background, it helps to squeeze out a little fresh paint into the wells of the palette. This freshens up the color in the well, and makes it easy to get rich, dark color. Squeeze out some fresh Sap Green, Raw Sienna, Burnt Sienna and Shadow Green then use the ½-inch (12mm) flat to bring out puddles of all of these colors. Wet the the small section of background at the back of the neck and paint in Raw Sienna with the ⅝-inch (16mm) flat. While still wet, add some Sap Green and finally Shadow Green. Let dry.

Switch to the 1½-inch (38mm) flat and wet the large background area on the right side. Begin with the lightest color, Raw Sienna. Each additional color will be darker and will contain less water than the previous. While still wet, add Sap Green over the entire area. Quickly add Shadow Green for the darkest area. Keep it really dark next to the eyes. Add a few brush strokes of Burnt Sienna for variety. Let dry.

Smooth and Soften

Make sure the background is completely dry, then use the ¼-inch (6mm) filbert to soften along the edge of the face, hat and back of the neck. Touch up any areas of the background along the edge that need filling in by adding more color.

Smooth the face and the neck with Burnt Sienna and Vermilion. Use the ⅝-inch (16mm) flat for the neck. Use Burnt Sienna in the dark area and switch to Vermilion in the lighter areas. Stroke lightly over the areas to smooth. This can be tricky, but with a little practice you will soon learn just how many times you can safely stroke over the color. In the neck area, keep your brushstrokes following the contour of the neck.

Smooth the face using a ½-inch (12mm) flat. Again, use Burnt Sienna in the dark areas and Vermilion in the lighter areas. Switch to the no. 8 round for the small areas. Lift a bit around the nose while smoothing. Let dry.

Bring out some straight Ultramarine Deep. With the ½-inch (12mm) flat, glaze over the shoulder of the dress and the dark areas of the hat. Let dry.

10 | Apply the Finishing Touches

Mix up a dark Ultramarine Deep and Burnt Sienna. With the no. 6 round, paint in the shapes for the smaller left eye and brow. Leave some white highlights showing in the lash and at the edge of the brow. Paint in the shapes on the other eye and brow. Leave some lights in the lashes. Soften with the tip of the no. 6 round. Let dry.

Use the ¼-inch (6mm) filbert to lift a bit of color from the white of the eye. Also lift color from the lower lids and from the shape under the eye on the cheek. (In my painting, this area had become a bit too dark.)

If needed, add more darks to the folds of the hat. If the small lights in the background of your painting seem distracting, you can do as I did and fill them in with background color.

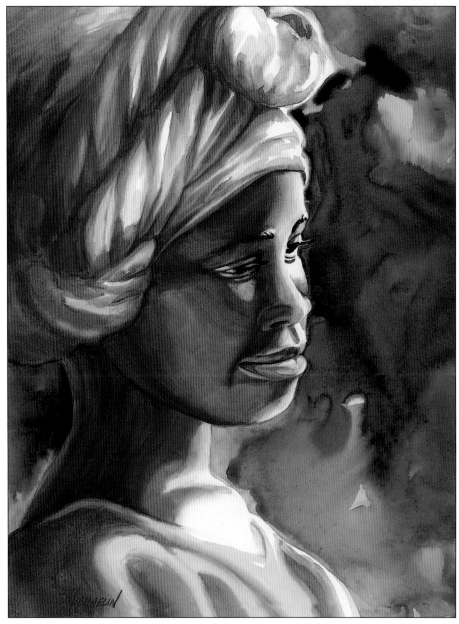

ASHRIEL • 15" x 20" (38cm x 51cm) •
Collection of the artist

Standing Youth

Carleen is from the Netherlands. She is also studying Indian dance. Her bright costume and lovely positioning make for great painting material. The photos used were taken outside in the bright sun, creating great shadows.

When painting the whole figure, the subject is farther away from the viewer than a portrait, so less detail is needed.

[MATERIALS LIST]

- Small piece of watercolor board, 15" x 20" (38cm x 51cm)

Paints
- Aureolin
- Raw Sienna
- Burnt Sienna
- Permanent Red
- Carmine
- Ultramarine Deep

Brushes
- No. 6 round
- No. 8 round
- No. 12 round
- ¼-inch (6mm) filbert

Other Supplies
- Water container
- No. 2 pencil
- White paper towels or tissues
- White eraser

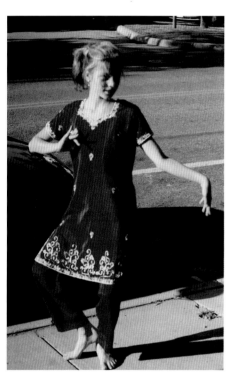

Reference Photo

1 **Draw the Standing Figure**
Draw Carleen on your board, including the shadow shape in the background. The horizontal background shape balances the strong vertical of the figure.

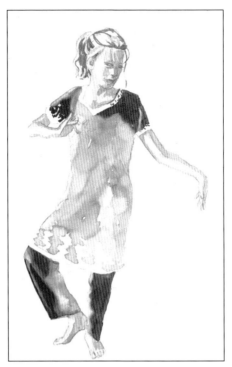

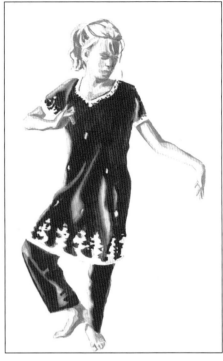

2 | **Paint the First Layer**
Use the no. 8 round to mix a watery wash of Aureolin and Permanent Red; for the basic skin tone. The mixture will look slightly orange. Paint the first skin tone layer, leave white streaks on the forehead for her hair, and white shapes on the cheek and neck. Continue with the arms and feet, leaving the white areas.

Add strokes of yellow into her hair with Raw Sienna and the no. 8 round, leaving lots of white.

Carleen is out in the sunshine, and we want that to show in the colors of her dress. Use Raw Sienna and the no. 8 round to paint the first layer on the shoulder of the dress. Switch to watery Carmine for the next area. Notice there are several Raw Sienna areas in the dress: on the shoulder, along the sunlit edge, on the large fold in front and one small area on the other sleeve. Leave the loose design white. Paint the pants in the same manner, with Raw Sienna along the sunlit edges, filling in with Carmine.

3 | **Add the Second Layer**
Mix Raw Sienna with Permanent Red for the second layer of skin, make this slightly darker than the first mixture. With the no. 8 round, paint the shapes on the face, arms and feet. Leave the white and the lighter areas unpainted.

Use the no. 8 round and Burnt Sienna for the second layer of hair. Leave the white and some Raw Sienna showing.

The second layer of the costume is painted with the no. 8 round and a thick mixture of Permanent Red. Start with the shape on the left sleeve and paint in the thick, intense red, then soften the edge with the no. 6 round. Paint the other shoulder and sleeve with the no. 8 round and soften the edge with the no. 6 round. Include a bit of detail in the white trim.

Paint the shapes on the pants. There are three separate shapes on the left leg, painted and softened, one at a time, and only one large shape on the right leg.

4 | **Add Another Layer of Skin Tone**
Use the no. 8 round and Permanent Red to finish all of the bright red areas of the dress; the edges are very easy to blend together with this color. Leave some of the Raw Sienna showing in the light folds. Let dry.

Mix Burnt Sienna and Permanent Red for the next layer on the skin. Because these are all small shapes, there is no need to soften. Use the no. 8 round and paint the shapes on the face, arms, hands and feet. There is a small shape under the chin and on the shoulder.

Tip *When painting the whole figure, the subject is farther away from the viewer than a portrait, so less detail is needed.*

82

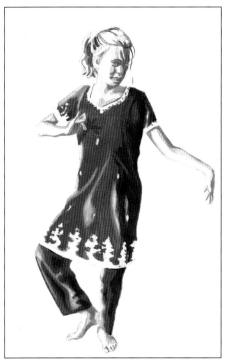 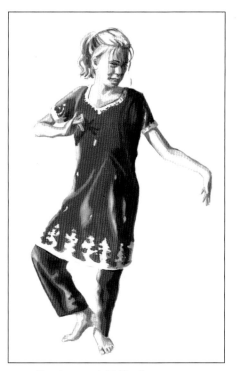 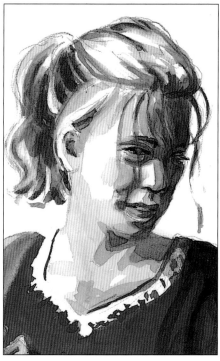

5 | **Add Dark and Cool Colors**

Since the dress is a warm red, some cool areas are needed. With the no. 8 round, bring out some Carmine (a cool red) and some Ultramarine Deep into two separate, fairly thick puddles.

Paint the shadows on the dress, first with Carmine then, while still wet, add Ultramarine Deep; soften the edges with the damp no. 6 round. Divide the shadows into smaller shapes to paint. Because the right hand is in such an interesting position, it makes the shadow on the dress very important. Complete all of the shadows on the dress and pants.

Finish the shadows on the face, mix Burnt Sienna with a little Ultramarine Deep and a touch of Carmine. Use the no. 6 round to paint the shadow on the side of the face and the small shadow at the corner of the mouth. Soften the shapes slightly with the tip of the no. 6 round. Add more Carmine to the mix and add some dark to the lips.

Mix Burnt Sienna with Ultramarine Deep and use the no. 8 round to add the darks to the hair.

6 | **Continue to Add Shadows**

There are some whites in the shadowed areas of the dress. Use the no. 6 round to lightly tint them with watery Ultramarine Deep. Start on the left sleeve and leave a small white area in the center. Paint a small shadow on the right sleeve. There is one on the shoulder and some on the shadowed left side of the dress.

Use the ¼-inch (6mm) filbert to slightly soften the hair and the white areas of the skin.

Use the no. 6 round to paint watery Ultramarine Deep in the palm of the hand, the dark side of the face and neck and on the arm.

7 | **Add the Face Details**

Paint the detail on the face with a black mixture of Ultramarine Deep and Burnt Sienna. Add just enough detail to make the shapes read as features. The detailed illustration will help you with the tiny shapes of the face. Fill in the inside of the mouth, leaving the teeth light.

8 | Paint the Background

All that is left to finish the painting is to paint the background. Whenever possible, you want the white areas on the figure to run into the white of the background to create lost edges. These edges create passages that direct your eye through the painting.

Wet the left side of the background with the no. 12 round. (Make sure to wet more than you intend to paint.) In order to keep the edge soft, you do not want the paint to reach the edge of the wet area. Use the same brush to lay in Ultramarine Deep in a light tone. While still wet, add Burnt Sienna to the bottom shape and Carmine to the top. Finally, add a little darker Ultramarine Deep. Let dry.

Wet the background area between the knees. Again, wet more than you want to paint. Some of the white should be allowed to merge with the background, so apply paint only to the small triangle right behind the right knee. Use the blue and then brown. Since the background colors on the left side of the knee are blue and brown, they should be the same colors on the right side of the knee.

Paint the Right Side of the Background
Wet the right side of the background, not including the dark shadow shape in the front. Lay in the colors with the no. 12 round in the same manner. Make the bottom shape a bit darker than the top one. Add color carefully around the hand. Let dry.

Add the Final Shadow
Wet the area between the feet and lay in thick Ultramarine Deep with the no. 8 round. Add some Carmine to the shape. Switch to the no. 12 round and

wet the large shadow to the right of the foot. Paint this front shadow darker than the back shape in the background. This will push the shape further into the background, and make the shadow of the figure come forward. Paint the shape Ultramarine Deep first, then add Burnt Sienna, Carmine and more Ultramarine Deep until the shadow is as dark as you want it. The painting of Carleen is complete.

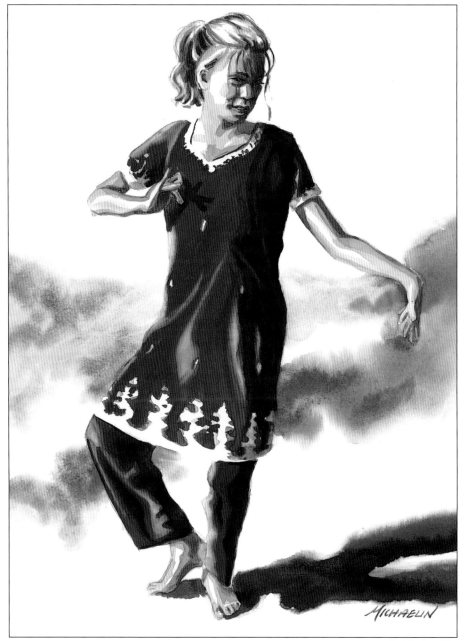

CARLEEN • 14" x 20" (36cm x 51cm) • Collection of the artist

Children Playing

Remember the photos on page 45 of the siblings playing?
You now have the chance to paint this delightful scene yourself.
You'll be amazed at how easy it is to make this fun and beautiful portrait.

[MATERIALS LIST]

◉ Small Piece of watercolor board, 15" x 20" (38cm x 51cm)

Paints

◉ Cadmium Yellow Lemon ◉ Indian Yellow

◉ Turquoise Blue ◉ Burnt Sienna

◉ Ultramarine Deep ◉ Carmine

Brushes

◉ No. 6 round ◉ No. 10 round

◉ No. 8 round ◉ No. 12 round

Other Supplies

◉ Water container ◉ White paper towels or tissues

◉ No. 2 pencil ◉ White eraser

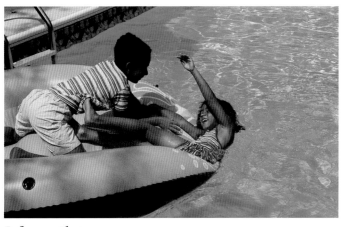

Reference Photo

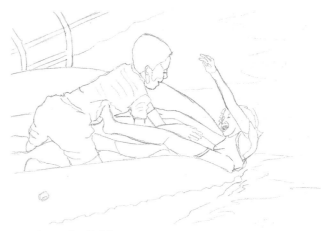

Draw the Children

1 | Draw the children playing in the swimming pool. Use the boy's head for your unit of measurement. Be careful to measure at the same angle each time. Include some shapes in the water. Do not add too much detail to the figures.

Tip Ultramarine Deep and Burnt Sienna are used to create a variety of colors in this painting—depending on how much of each color you use in the mix. Experiment mixing the two colors in differing amounts so that you know how to mix a gray, black, or a dark brown as needed.

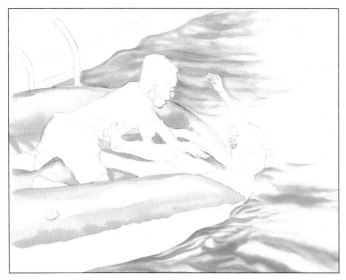 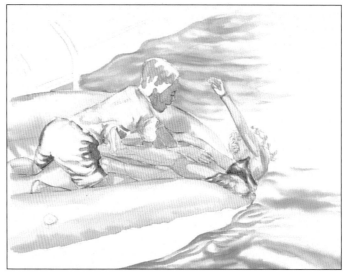

2 | **Paint the Raft**

Use the no. 12 round and bring out Cadmium Yellow Lemon and Indian Yellow onto your palette. Paint the raft one shape at a time. Wet the shape behind the boy's back, including the area behind his leg. With the no. 12 round, paint the lighter areas using Cadmium Yellow Lemon, leaving the highlighted areas white. While still wet, use the same brush to lay in Indian Yellow shadows. Paint each area separately, using the no. 8 round for the smaller shapes and the no. 12 round for the larger ones. The smallest shapes do not need to be wet first. After all of the other areas dry, paint the largest front shape. Add a small shadow in Indian Yellow around the valve.

Paint the Water

Bring some Turquoise Blue out onto the palette. With the no. 12 round, wet the entire bottom section of the water; make sure to wet more than you will actually paint. Use the no. 10 round to paint the shapes in the water. Let them bleed slightly. As the surface dries, add smaller shapes. Soften with the same brush as needed. Make sure the strokes go in the direction of the water. Where the water is smooth, make the shapes horizontal. Where the water is agitated, make them go in different directions. Turquoise Blue is a non-staining color, so you can soften and lift easily. Let dry.

Wet the top section of the water with the no. 12 round. Paint the Turquoise Blue with the no. 10 round, softening as needed.

3 | **Add More Color**

Mix a watery Burnt Sienna and Carmine for the skin tone. Use the no. 8 round and paint the first layer on all of the skin, leaving the white areas and softening with the damp no. 6 round. The boy's face is in shadow, so there are no white areas on it. Paint and allow each area to dry before painting an adjoining area.

Paint the hair with the no. 8 round and Burnt Sienna. The Burnt Sienna will be the highlights in the dark hair. The girl has very curly hair, so make your brushstrokes small and circular.

Paint the Clothing

Still using the no. 8 round, paint the shadow shapes on the boy's white shorts with a mixture of Ultramarine Deep and a small amount of Burnt Sienna; soften as you go with the damp no. 6 round.

Mix Carmine with a bit of Turquoise Blue with the no. 8 round and paint the girl's outfit. Paint the shadowed areas, leaving the white areas; soften with the no. 6 round.

Mix a light gray with Burnt Sienna and Ultramarine Deep. Also mix Indian Yellow and Burnt Sienna. Use the no. 8 round and these two colors to shade the shirt. This will make the shirt both cool and warm. Soften as you go with the no. 6 round.

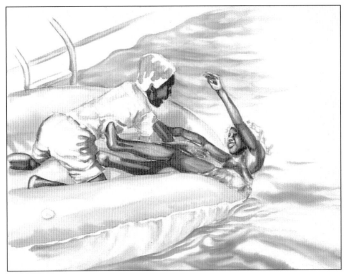

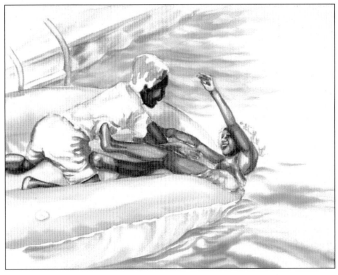

4 | Add Darker Shapes

Mix a darker Burnt Sienna and Carmine (than step three). Use the no. 6 round to add small, dark shapes to the skin and soften with the same brush. While still wet, add even darker, smaller shapes.

With the light gray mix of Burnt Sienna and Ultramarine Deep, paint the pool ladder. Use the no. 8 round to wet a section and paint each side of the pole (paint each section separately). Use the damp no. 6 round to brush down the center of the two lines to soften and make the pole appear round. Paint the front of the step and a line on top with the no. 8 round, then soften with the no. 6 round. Let dry.

Wet the edge of the pool and paint in the same way. Add a stripe of reflected Turquoise Blue along the bottom edge.

The folds on the bottom of the raft are painted with Ultramarine Deep mixed with a small amount of Burnt Sienna. Wet with the no. 10 round and paint the folds in the vinyl; use the same brush to soften if needed. Add a little reflected Turquoise Blue on the bottom.

5 | Add Shadows

Wet the side of the pool with the no. 10 round. Add some gray shapes using the same color as the ladder. While still wet, paint some shapes of Burnt Sienna onto the side of the pool and in the water. Wet the ground area above the edge of the pool and lay in some gray only.

Paint the shadows on the skin and raft with the no. 8 round and Ultramarine Deep. Start at the back of the boy's knee and paint the shadow on the skin continuing onto the yellow of the raft. Soften with the no. 6 round.

Paint the shadow shape on the girl's bottom leg with the no. 8 round, running it into the yellow area under the leg. Soften with the no. 6 round. Paint the boy's left arm. Add the shadow underneath the boy's arm that is on the raft. For the boy's face, use the no. 6 round to add Ultramarine Deep to the shadows, then instead of softening, add skin tone color to the lighter areas. Let some of the dark blue on the face run right up into the hair. Paint the boy's front leg with the no. 6 round and Ultramarine Deep; soften if needed.

Paint the shadow on the girl's face that is from her arm. These shapes run into the contour of the face and under the chin. Soften the edges with the damp no. 6 round. Paint the inside of the mouth with Carmine mixed with the gray mixture of Ultramarine Deep and Burnt Sienna. Leave the teeth white.

Tip Remember when the subject is farther away from you, less detail is necessary.

6 **Strengthen the Shadows**

Paint the small shadow shapes one small section at a time with Ultramarine Deep. Use the no. 6 round and shadow the upper part of the boy's right arm continuing down into the raft. Add the shadow to the boy's lower arm that is created by the girl's leg. Bring this shadow under and onto the raft (notice the small shadow on the raft under the finger) then soften.

Paint the shadow on the girl's right hand and shoulder and the small shadows on her left arm, hand, and shoulder then soften. Paint a few little shadows on the fingers. Paint the shadow shape on the girl's right (lower) leg, behind the knee and down the calf (including the small shadow shapes on the foot). Also paint the shadows on her left leg.

Use the no. 6 round and Burnt Sienna mixed with Indian Yellow to paint the valve and small shadow on the left side of the raft (behind the boy). Add the same yellow mixture to the shadow of the boy's head on the raft near the girl's right hand.

Paint the Hair and Eyes

Using the no. 8 round and a thick, brown mixture of Ultramarine Deep and Burnt Sienna paint the boy's hair, leaving some of the original Burnt Sienna showing. Paint the girl's hair the same color using short, curly strokes. Let dry, then soften here and there with the tip of the damp no. 6 round.

Use the no. 6 round and a thick mixture of Ultramarine Deep and Burnt Sienna to paint in the small eye shapes. Add some darker, thicker Carmine under the eye and chin.

Strengthen the Darks

Use the dark brown to add shadow shapes to the boy's shirt. Use the no. 8 round and while still wet, add some Ultramarine Deep here and there. Soften the edges with the no. 6 round.

Using the same brush, darken the girl's clothes using Carmine mixed with the black mixture used on the eyes. Also add some Turquoise Blue shapes onto the pink and add some behind her back to put part of her into the water.

With the no. 8 round, add Turquoise Blue stripes to the boy's shirt. Follow the folds of the fabric; do not make them straight. Slightly darken the folds on the bottom section of the raft with the gray mixture and add some Turquoise Blue.

Add Reflections

The bright yellow of the raft reflects onto the skin and clothing; use the no. 8 round and add a streak of yellow to the boy's back leg and some to the back of the shorts; also add some to the girl's left leg. Lastly, add a reflection of skin color onto the raft under the girl. With the no. 8 round, paint a stripe of skin tone and soften.

SIBLING RIVALRY • 14" x 18" (36cm x 46cm) •
Collection of Allen and Theresa Bush

Group—Little Cowboys

These cute little cowboys are the grandchildren of one of my students. The photo inspiration for this painting made me really wonder what they were looking at, or perhaps, looking forward too. Even though it is posed, rather than candid, it tells a story. Also, the black hats and jackets make a great dark shape that visually connects them.

[MATERIALS LIST]

◉ Small piece of watercolor board, 15" x 20" (38cm x 51cm)

Paints

◉ Raw Sienna ◉ Permanent Red

◉ Burnt Sienna ◉ Ultramarine Deep

◉ Carmine

Brushes

◉ No. 6 round ◉ No. 10 round

◉ No. 8 round ◉ ¼-inch (6mm) filbert

Other Supplies

◉ Water container ◉ White paper towels or tissues

◉ No. 2 pencil ◉ White eraser

Reference Photo

1 | Draw the Figures

Draw (or enlarge and trace) this drawing of the cowboys on your board.

Tip Leaving some white areas on the fingers help to suggest the bend in the fingers.

2 | Add the First Layer

Paint the first layer of skin with a watery mix of Raw Sienna and Permanent Red. On dry paper, use the no. 8 round and cover all of the skin except the white areas. Let dry.

 With the no. 10 round, mix Burnt Sienna with a small amount of Ultramarine Deep to make a soft brown. On dry paper, paint the first layer on the pants of the boy on the left. Paint the pants and shirt of the boy in the center. Leave lots of white to indicate folds in the fabric.

 The boy on the right is wearing a one-piece suit. Use Ultramarine Deep to loosely paint his clothes with the no. 10 round. Leave white areas. Let dry.

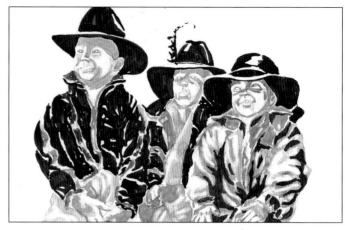

3 **Paint the Fabric**

Use the ¼-inch (6mm) filbert to soften all of the white edges in the skin as well as all of the fabric. The clothes should already appear to have folds.

With the no. 8 round, paint the lining and accents of the center boy's jacket. Leave white areas.

Still using the no. 8 round, paint the lining and trim of the jacket on the right with Permanent Red.

The stripes on the jacket on the left are painted red; use the no. 8 round and Permanent Red. By making them wavy and leaving white areas, the stripes appear to go with the contour of the fabric.

4 **Add Black**

The second, darker coat on the skin is another layer of Raw Sienna and Permanent Red (same as used in step one). Use the no. 6 round to paint in the darker shapes. Leave the edges crisp.

The real fun begins with the black. Mix a large, thick puddle of Ultramarine Deep and Burnt Sienna. Use the no. 10 round and start with the hat on the left, then work your way across. Leave the white areas for highlights and folds. Use the same mix and the no. 8 round to paint the darks in the folds of the blue suit; add shapes to indicate the feather.

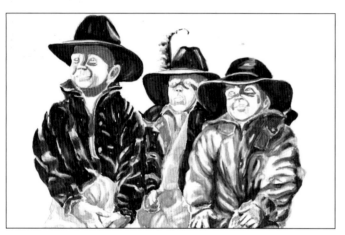

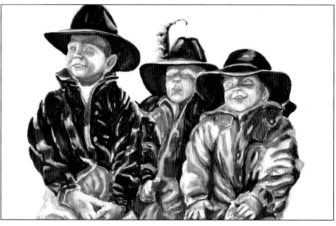

5 **Soften the Edges**

Use the ¼-inch (6mm) filbert to soften the edges of the hats and clothes. Rinse often, as the brush will pick up this dark color. You will be able to pull a little of the black over the red stripes to shade; add more Permanent Red if needed. This technique really makes shading easy since you are actually sculpting the clothes with the filbert.

Soften the feather and pull some paint out into the white to make some of the edges soft.

Mix the skin color again (Burnt Sienna and Carmine) and add another layer on the skin with the no. 6 round.

6 **Add More Darks**

With the no. 10 round, mix dark brown with Burnt Sienna and Ultramarine Deep. Paint the darker brown on the brown pants and shirt. Let dry and soften with the ¼-inch (6mm) filbert.

Soften the edges of the darker shapes on the skin with the no. 6 round. Since this brush has a small, pointed tip, you have more control over tiny areas than with the filbert.

Add more Carmine to the skin tone mixture and use the no. 6 round to paint the lips and outline the teeth. Let dry and soften along the teeth.

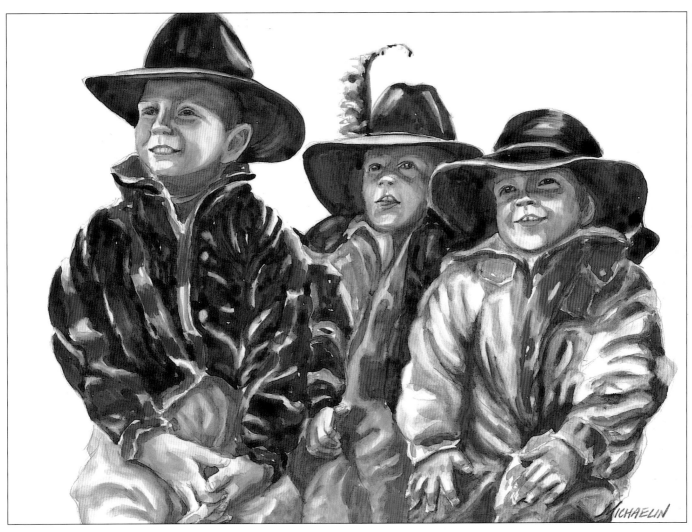

Add the Finishing Touches

7 | Use the no. 6 round and dark brown to paint the details on the faces. Paint the lines around the eyes and lids and soften with the tip of the brush. Paint the nostrils with the dark brown and soften.

Use the black mixture to paint the pupils of the eyes. Leave a white highlight if possible (if your highlight is not there, you can put it in later).

Use the dark skin tone color to darken any shadows around the eyes that appear too light. Let dry.

Use a watery glaze of Ultramarine Deep to put the last shadows on the skin. With the no. 8 round, glaze the areas under each hat, over the ears, under the chins and a few small shadows on the hands (under the cuffs). Add small spots of Burnt Sienna to the feather with the no. 6 round and soften (this will add some warm to the cool feather).

If the highlights in the eyes are gone, as mine were, it is easy to put them back in. Use the corner of a razor blade to pick off small highlights in the darkest part of the eyes. The last step for *Tres Amigos* is to add a small amount of Carmine to the cheeks. Use the no. 6 round and add some watery pink to each face.

TRES AMIGOS • 10" x 15" (25cm x 38cm) • Collection of the artist

Conclusion

One thing that remains difficult for all artists is judging their own work. Is it done? Is it good enough to frame? Should I start over?

One of the best ways to find the answer to these questions is to ask someone else; even the most accomplished artist sometimes needs a second opinion. After working so closely to the painting you no longer look at it objectively, so a fresh opinion can really help. Of course, by doing this you also open yourself up to criticism. So first decide if you really want another opinion. If you like it and are satisfied that you accomplished your goals for the painting, leave it alone. But if you are not sure, and are open to hearing another opinion, it may help to get one.

Many artists find it helpful to paint with a group who allow time for feedback and critiques; especially for beginners. In a classroom setting, you can get help from the instructor as well as from fellow students. You become a real support group for each other. Some of my ongoing classes have been together for years, they are all fast friends and probably don't even need me anymore. But most still find it very helpful to have fresh eyes to look at their work; not to mention that we think it's just plain fun painting in a group!

When you finish a painting, put it up where you can see it frequently during the day. After you have seen it for a day or two, you will know whether you are satisfied with it or not. If, after a period of time, you still like it, consider it done. If you still have doubts, ask for a second opinion. Once I have looked at a painting for a while, often I can figure out what might be bothering me—but not always. I frequently ask artist friends to help and they can usually zoom right in on the problem area.

Don't make the mistake of comparing your painting to the photo from which it was created. When it is framed on the wall, people are not going to see that photo, the painting needs to stand by itself and make sense on its own.

Learn From Your Mistakes

Try not to let mistakes or failed paintings discourage you. Any skill takes time to learn, and painting is truly a learned skill. Even the greatest artist was not born knowing how to paint. Someone, or a great amount of time and practice, taught them. Why is it that when we take piano lessons, we do not expect to play a concerto the first day, but we expect every painting to turn out perfect and be framed? You need to get over that belief. Everything, including watercolor, takes practice. Consider the journey just as much fun as the destination. If a painting did not turn out, so what? From it you learned great lessons and will do a better one next time. Remember, it is just a piece of paper, or board in this case. So relax and have fun; you can always turn it over and paint on the other side!

The first attempt at *Dona Isabel II* turned out all right, but had a lackluster effect. The large white shape running through the painting was awkward and uninteresting.

Dona Isabel II was reworked and darkened. The white shape was changed and more color added to the subject. The result is a much more vibrant and interesting painting.

DONA ISABEL II • 24" x 30" (61cm x 76cm) •
Collection of the artist

Critique Yourself

As a painter it is important to learn how to critique your work. This means really looking at it as if someone else had painted it. Having someone else look at your work is also helpful, but it is your painting and you should decide what the final result will be. You are the final judge.

Art is very subjective. What one artist feels is a good painting may not appeal to another at all. I have won a "Best in Show" award on one painting only to have another judge not even select the same painting to be in the next show. Developing enough confidence to know your work is good, no matter what someone else feels or says, takes time and a lot of painting. Let your heart rule the final decision maker.

The painting of Adonai is a good example of learning from mistakes. This painting was framed and hanging in my gallery for about a year. People admired it, but most didn't give it a second look. I decided to take it out of the frame and really look at it again.

After consideration, I decided that the figure got lost in the large busy background. While I wanted it vibrant and active, it overwhelmed the boy. So I started playing with different size mats. I decided it appeared as a much stronger painting with a good part of the background cut off. So I trimmed the picture and reframed it smaller than the original. The painting was accepted into the next show that I entered and was quickly sold there. The decision must have been the right one.

Have Fun!

Most important of all is to have fun. Painting should be relaxing, like going on vacation. While painting, you are completely removed from the realities of life. Leave all of your troubles at the door of your studio and escape into the world of creating a painting. Learn from your mistakes as you enjoy the process and the feeling of accomplishment as you improve with each painting. And with practice, I guarantee you will succeed. Happy painting!

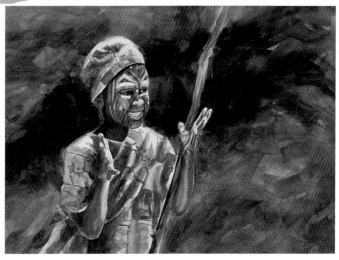

This figure painting of Adonai was happy and active, but something was missing. He seemed lost in the large background.

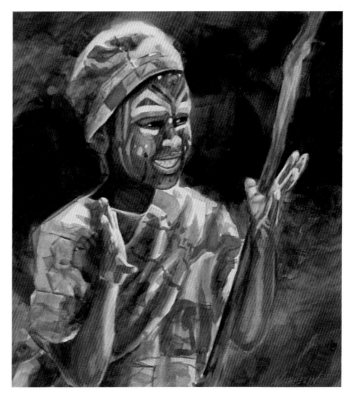

After cropping the picture, it became a better composition. Now the viewer really looks at the figure, which gains much more importance. Nothing was changed on the actual painting, but it has vastly more impact in a smaller size.

ADONAI • 18" x 22" (46cm x 56cm) •
Private collection

93

Index

The best in fine art instruction is from North Light Books!

Begin your watercolor journey by mastering the basics with Mark and Mary Willenbrink. This highly visual guide will lead you through demonstrations on proper brush technique and planning a painting while focusing on fundamental topics such as materials, value, color and composition. 15 easy-to-follow projects will spark your creative expedition with watercolors.

ISBN 1-58180-341-9, paperback, 128 pages, #32310-K

Overcome the elusive challenge of rendering realistic skin tones in your portraiture. Whether your subject is Caucasian, Asian, African-American or Hispanic you will find practical guidance on how to successfully depict each one's distinct beauty. Lessons and demonstrations in oils, pastels and watercolors teach you how to mix colors, work with light and shadow and edit your compositions for glowing portraits you'll be proud of.

ISBN 1-582-180-163-7, hardcover, 128 pages, #31913-K

Beautifully illustrated and superbly written, this wonderful guide is perfect for watercolorists of all skill levels!

Gordon MacKenzie distills over thirty years of teaching experience into dozens of painting tricks and techniques that cover everything from key concepts, such as composition, color and value, to fine details, including washes, masking and more.

ISBN 0-89134-946-4, hardcover, 144 pages, #31443-K

The spontaneous nature of watercolors can simplify your paintings. 16 step-by-step demonstrations show you how to capture a variety of subjects with a loose, direct painting style while building your confidence and skill. The basics of good painting—composition, drawing, value, and color—are stressed to illuminate your work. You'll also find a technique for mixing color directly on the page to produce rich, vibrant hues.

ISBN 1-58180-350-8, hardcover, 128 pages, #32321-K

These books and other fine North Light titles are available from your local art & craft retailer, bookstore, online supplier or by calling 1-800-448-0915.